132

44

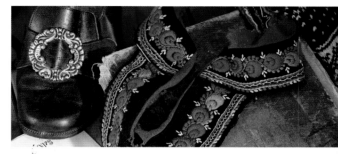

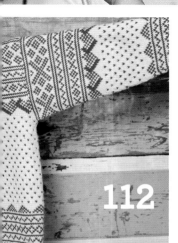

112

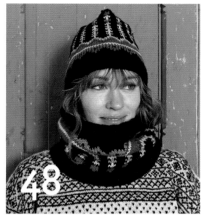

48

CONTENTS

97

70

YARNS

Rauma yarn currently ships to the UK from the following Scandinavian or American distributors:

Helylle Hantverket (Sweden)
http://helylle.se/in_english/
info@helylle.se.

Yllotyll Garnbutik (Sweden)
info@yllotyll.com

Strikk (Sweden)
info@strikk.se

Nordic Fiber Arts (USA)
info@nordicfiberarts.com
www.nordicfiberarts.com

An alternative yarn brand that can be substituted for Rauma yarn and which is distributed within the UK is Sandnes yarn. Sandnes yarn is distributed by SKD yarns:

SKD Yarns (Scandinavian Knitting Design Ltd.)
www.skdyarns.net/
sales@scandinavianknittingdesign.com

BIBLIOGRAPHY

Bondesen, Esther. *Den Nye Strikkeboken* [The New Knitting Book]. Oslo, Norway: Ansgar Forlag, 1948.

Høye, Gert M. *Sosialmedisinske undersøkelser i Valle*, Setesdal [Social Medicine Research in Valle, Setesdal]. Oslo, Norway: A. W.Brøggers Boktrykkeri A/S, 1941.

Noss, Aagot. *Stakklede i Setesdal* [Folk Costumes in Setesdal].Oslo, Norway: Novus Forlag, 2008.

Sibbern Bøhn, Annichen. *Norske Strikkemønstre*. Oslo, Norway, 1929, 1947. *Norwegian Knitting Designs*, reprint, Seattle, 2011

Skar, Johannes. *Gamalt or Setesdal I, II, and III* [Old Ways in Setesdal]. Oslo, Norway: Det Norske Samlaget, 1963.

Sundbø, Annemor. *Lusekofta fra Setesdal*. Oslo. Norway: Høyskoleforlaget AS, 1998. *Setesdal Sweaters: The History of the Norwegian Lice Pattern*. Kristiansand, Norway: Torridal Tweed, 2001.

Sundbø, Annemor. *Strikking i Billdekunsten/Knitting in Art*. Kristiansand, Norway: Torridal Tweed, 2010.

Sundbø, Annemor. *Kvardagsstrikk*. Oslo, Norway: Det Norske Samlaget, 1994. *Everyday Knitting: Treasures from a Ragpile*. Kristiansand, Norway: Torridal Tweed, 2000.

Sundbø, Annemor. *Usynlege trådar i Strikkekunsten*. Oslo: Det Norske Samlaget, 2005. *Invisible Threads in Knitting*. Kristiansand, Norway: Torridal Tweed, 2007.

Svensøy, Kari Grethe. *Det va inkje hobby; det var arbeid*. Tekstilarbeidet i Bykle ca 1900-1935 [It wasn't a Hobby, it was Work: Textile Work in Bykle from about 1900-1935]. Magisteravhandling i etnologi. Institutt for Etnologi. Universitet i Oslo. 1987.

Norsk Folkemuseum. *Setesdalen*. Kristiania (Oslo), Norway: Alb Cammermeyers Forlag. Lars Swanström. 1919.

Thank you to **Bodil Svanemyr** for her invaluable help with developing the patterns for the sweaters, stockings, and mittens. Thank you also to **Laila Kristin Wilgunnsdottir Bøhle** and **Britt Aasen Brude** for help in knitting the models. We would never have accomplished this book without you!

If you want to see more pieces in the Christmas service, see www.fyrklovern.se.

PREFACE

Arne's grandmother was from Setesdal. Her name was Torbjørg Heistad and she was born in the parish of Austad in Bygland on July 7, 1895. It was a long way to Sørlandet when Arne was a child and even further up to Setesdal. It wasn't until he was an adult that he made it to Byglandsfjord and found a ramshackle house behind the birches and underbrush. A house where children had played and painted on the walls and where wood ants—and plenty of them—were now the only inhabitants.

In the attic, the floor was covered with old magazines, letters, and Christmas cards. On top of all the rubbish lay a picture of Arne's mother when she was young, a picture she had certainly sent to her grandmother. He took the picture with him when he left.

Many years later, we met Annemor Sundbø outside the Opera House in Oslo. We had arranged to meet there to talk about knitting, and she told us that she had also been in the same attic where she found a Christmas card that she reproduced in her book, *Knitting in Art*.

This book is based on the textiles, patterns, and books from our collection. Much of the inspiration came from the attic of the old house, in pictures we found in old books and on postcards, and in old knitting patterns and books.

An attic is not only the highest room in a house but also the house's second floor. In the old days, it was common to use the first floor as the living space and the attic as dressing rooms and bedrooms. The house was like a two-story storehouse:

"He brought in carpenters from Holland to build the attic. It was well made overall. The lumber was finely hewn, planed, and finished. It was covered with green fabric; *vadmal* (fulled woven fabric) was most common. One wall up in the attic was covered with pictures from foreign countries."

Finally, we should also say a few words about how we work: We wholeheartedly believe that one should anchor new designs in the old traditions. That is what happens when we go back in time and examine our cultural heritage and history—we can bring something back to incorporate into our work and create something new. At the same time as we create something new, we are also contributing back to the old traditions.

The 33 patterns in this book have been inspired by Setesdal's cultural heritage and patterns—but they were designed with our own twist. We hope everyone will be as inspired by *Knitting Scandinavian Style* as we have been. We wish you all good knitting!

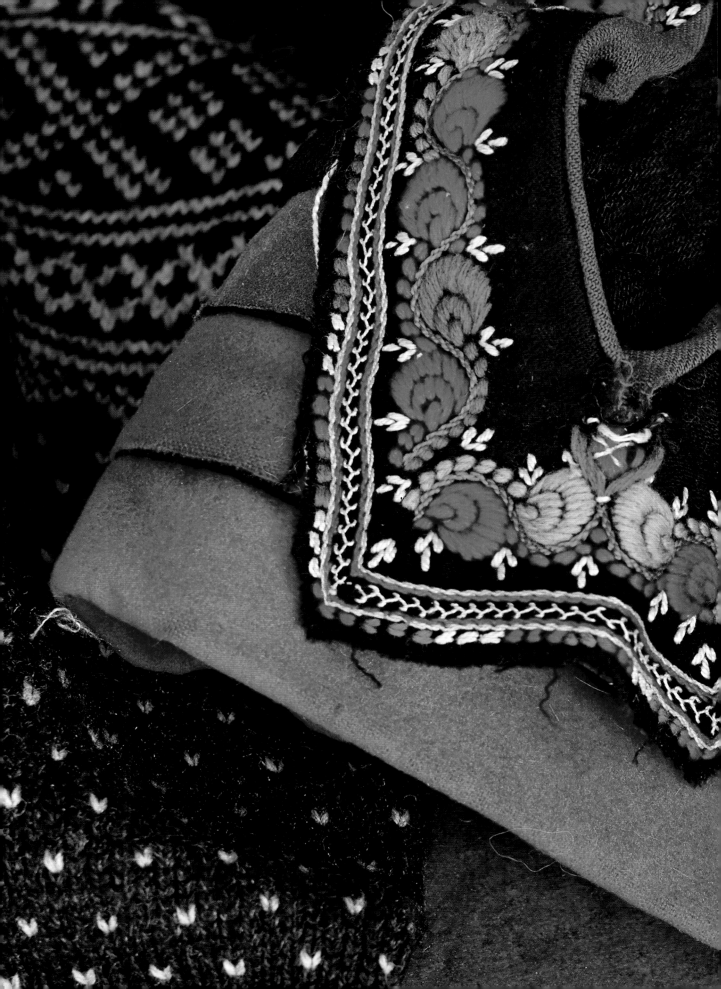

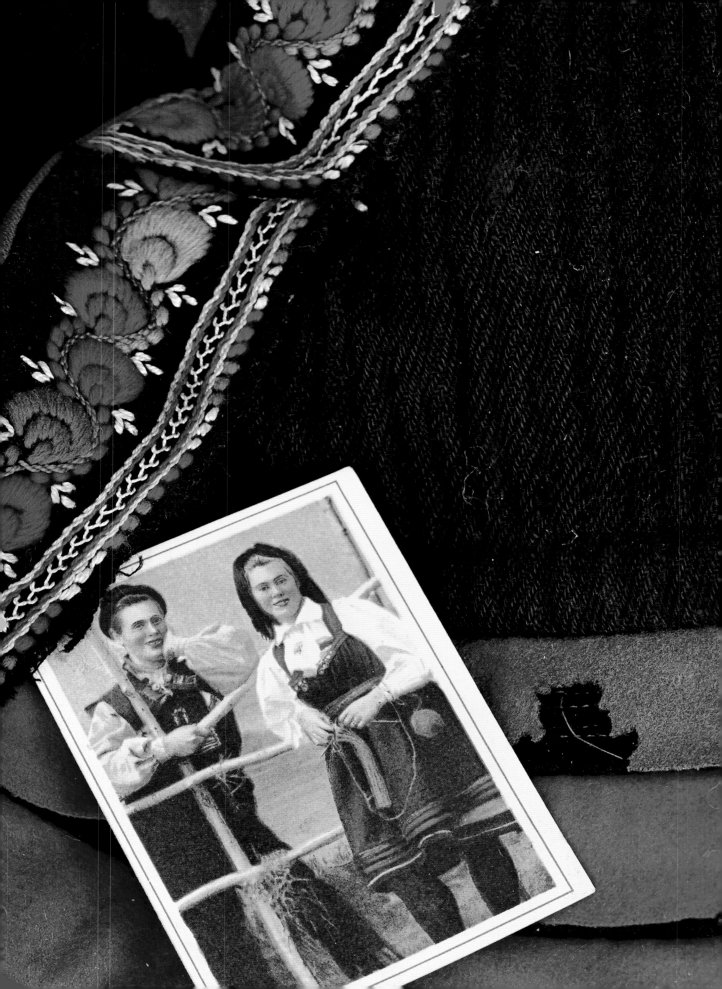

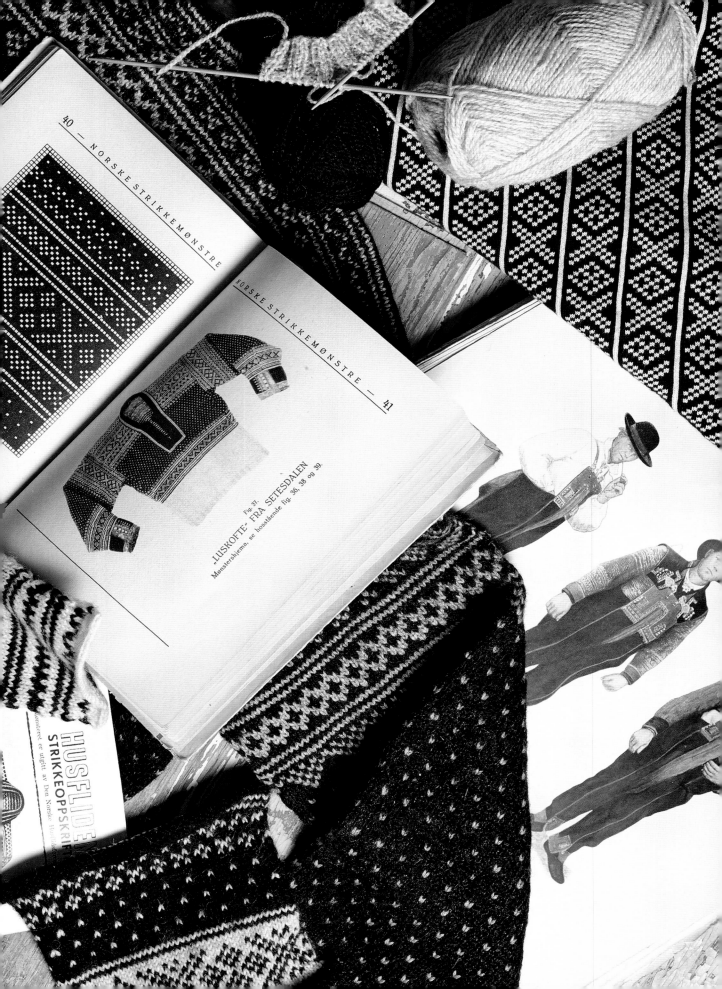

Fig. 37.
„LUSKOFTE" FRA SETESDALEN.
Mønsterskjema, se hosstående fig. 36, 38 og 39.

HUSFLIDEN
STRIKKEOPPSKRIF
Mønsteret er utgitt av Den Norske Husflid

LICE SWEATERS

Lice sweaters (*lusekofta*) from Setesdal have a long tradition in Norway and have been knitted in Setesdal since the middle of the nineteenth century. The patterns on the Setesdal sweaters are the most recognizable in the Norwegian knitting tradition and have come to symbolize the "authentic Norwegian" elsewhere in the world.

"They had begun to wear the 'easterner's clothing' in Setesdal, and they put on so much silver that the garments became terribly heavy. But the teachers kept to the old ways: Olav Halvorsson and Bjug Åkre sold all their silver and vowed never to adorn children with silver. Tor Bjørguvsson and Olav were the last men to wear loose sweaters and short pants in Valle."

The Norwegian version was loosely translated from Johannes Skar, *Gamalt or Setesdal* [Old Ways in Setesdal]

SETESDAL
SWEATERS

There are some old motifs that are always included on Setesdal sweaters and which give them their characteristic look.

A *lusekofte* or "lice sweater" should have the cross and ring ["kross (or kors) og kringle"] pattern, and this is the "value mark" of the sweater. The cross is named for Andrew, one of Jesus' disciples. He was condemned to death by being fastened to a cross but chose a cross in the form of an X because he believed that he was not worthy of dying in the same manner as Jesus. The ring symbolizes life's wheel, the sun symbol—the eternal, life-giving source of energy.

The next motif which is found on Setesdal sweaters is the zigzag border that is often called a "hook border." This border is older than the cross and ring patterns. The zigzag symbolizes cleansing water, life's water, or the gospel.

The lice (evenly distributed individual white stitches on a black background) are also characteristic of these sweaters. They decorate the sweater while also making it warmer. Traditionally, the sweater was always knitted with black, which was considered the finest color, while the lice and all the other patterns were knitted in white.

In addition, the sweaters were decorated with embroidery, *løyesaum*. Today there are very few people who know the art of this embroidery since the patterns were never drawn by hand but were sewn free-hand. While it was always possible to improvise and make choices regarding color and decorative experiments as the embroiderer worked, the embroidery was also determined by very strict forms and rules. Sometimes the sweater might be edged with green felt fabric.

The lower part of a Setesdal sweater was always white. White wool was the cheapest and the sweater would always be tucked down into the high trousers worn by men so the lower edge was never visible and no one knew it was knit with a cheaper color. Many of the older people in the area thought it was unseemly to show the white section of a sweater since it was regarded as underclothing. When the knitted sweater came to Setesdal, they had already begun yarn dyeing. Before that time, they only wore a short *vadmal* (heavily fulled woven fabric) garment with a small amount of embroidery.

In *Gamalt or Setesdal*, the Austmann sweater is noted as the knitted sweater that became fashionable in Setesdal. The "easterners" (Austmen) are from Telemark—although the name has several connotations, most likely this knitted fashion came over the mountains from Telemark.

The Setesdalers took to machine knitting early on, which helps to explain why the sweaters almost exploded on the market at the end of the 19th century. Those who had knitting machines knitted mostly for others, either for trade or cash. Annichen Sibbern Bøhn wrote the book *Norwegian Knitting Designs* in 1929 and featured the first published pattern for a Setesdal sweater. The book contributed to the popularity of the Setesdal sweaters which continues to this day.

This is just a short excursion into the history of the Setesdal lice sweater. If you want more information about this fascinating history, we recommend that you read Annemor Sundbø's excellent book, *Setedal Sweaters: The History of the Norwegian Lice Pattern*, published by Torridal Tweed in 2001 (the original Norwegian edition was published in 1998 by Høyskoleforlaget). We used her book as our reference for the material in this chapter.

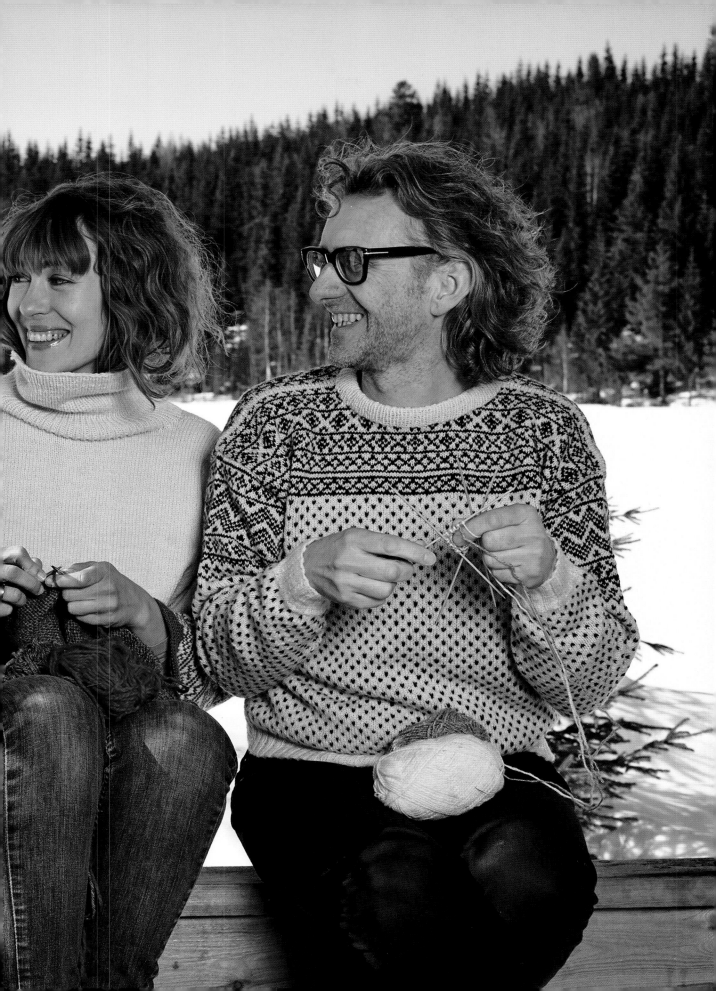

MATERIALS

In this chapter, we try to provide as much detailed information as possible about the materials we used. At the back of the book (on page 142), you'll find a resource list suggesting good quality yarns for the projects. Contact the yarn company for your nearest distributor.

YARN

We used the following Rauma yarns for the projects in this book:

Finullgarn

100% pure new wool, woolen-spun yarn in a large assortment of colors (fingering weight, 191 yd/175 m / 50 g).

3-ply Strikkegarn

100% pure new wool, high quality woolen-spun yarn (DK weight, 115 yd/105 m / 50 g). We used this yarn for the double knitting projects in Chapter 9.

Vamsegarn

Vamse, 100% wool (Aran weight, 91 yd/83 m / 50 g), is heavier than Finullgarn. We used Vamse for knitting pillows, hats, and one of the men's sweaters.

PT5

A somewhat heavy sportweight yarn that is very soft and especially nice to knit with. PT5 is 80% wool, 20% nylon (sportweight, 140 yd/128 m / 50 g). This durable yarn is particularly good for places that get extra wear or stress. We used this yarn for socks and the neck warmer.

Mitu

A delightful 50% superfine alpaca and 50% wool yarn (DK weight, 109 yd/100 m / 50 g). We have had good experiences with this quality yarn. What is nicest about an alpaca-wool blend is that you get the best of both fibers: The wool makes beautiful, light garments because the fiber is lofty but compact, and the alpaca adds extra softness and luster to the yarn.

PT Pandora

We used this cotton yarn for the knitted necklace. PT Pandora is 100% cotton (fingering weight, 180 yd/165 m / 50 g).

KNITTING NEEDLES, CROCHET HOOKS, AND OTHER TYPES OF NEEDLES

You will need:
Knitting needles: U.S. sizes 1-2, 2-3, 4, 7, and 8 / 2.5, 3, 3.5, 4.5, and 5 mm

Circular needles: U.S. sizes 1-2, 2-3, 4, 7, 8, 9, 10, and 10 ½ / 2.5, 3, 3.5, 4.5, 5, 5.5, 6, and 6.5 mm

Tapestry needle and thick blunt-tipped needle for the large pillows

Crochet hook: U.S. size D-3 / 3 mm

Fiber Fill
As usual, we stuffed the necklace and teddy bear with wool fill. We used commercially made pillow forms (23¾ x 23¾ in / 60 x 60 cm) for the pillows knit with Vamse yarn. You can buy pillow forms at any good fabric shop. We stuffed the draft stoppers with fiberfill from Coats.

ABBREVIATIONS

BO	bind off	M1L	Make 1 Left: lift strand between stitches from front to back and knit into back loop
cm	centimeter(s)		
CO	cast on		
dec	decrease(s)(ing)		
dpn	double pointed needleas	M1R	Make 1 Right: lift strand between stitches from back to front and knit into loop
in	inch(es)		
k	knit		
k2tog	knit 2 together	M1p	Make 1 purlwise: purl into front and then back of same stitch
LLI	Left Lifted Increase: knit into left side of stitch below stitch just worked		
		mm	millimeter(s)
		p	purl
m	meter(s)	psso	pass slipped st over
M1	Make 1—if not specified in pattern, work M1L	rem	remain(s)(ing)
		rep	repeat
		RLI	Right Lifted Increase: knit into right side of stitch below first st on left needle

rnd(s)	round(s)
RS	right side
sc	single crochet (= British double crochet)
sl	slip
sl 1, k1, psso	slip 1 knitwise, knit 1, pass slipped st over
ssk	slip, slip, knit: (sl 1 knitwise) 2 times, insert left needle tip knitwise into sts and knit together through back loops
st(s)	stitch(es)
tbl	through back loop(s)
WS	wrong side
yd(s)	yard(s)
yo	yarnover

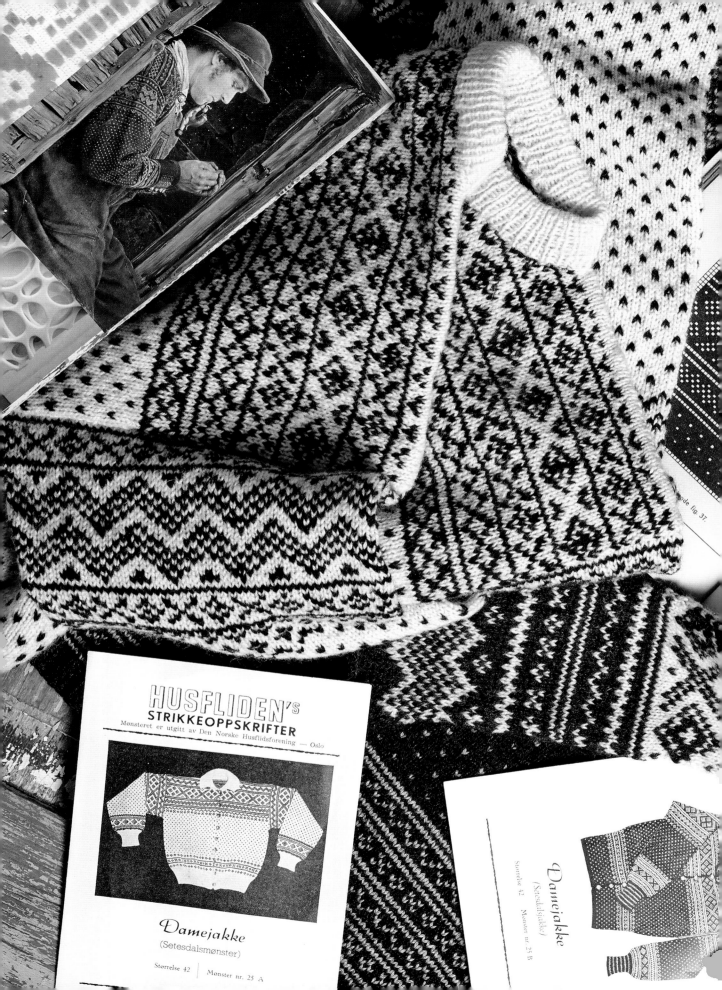

HUSFLIDEN'S
STRIKKEOPPSKRIFTER
Mønsteret er utgitt av Den Norske Husflidsforening — Oslo

Damejakke
(Setesdalsmønster)

Størrelse 42 | Mønster nr. 25 A

Damejakke
(Setesdalsjakke)

Størrelse 42 | Mønster nr. 25 B

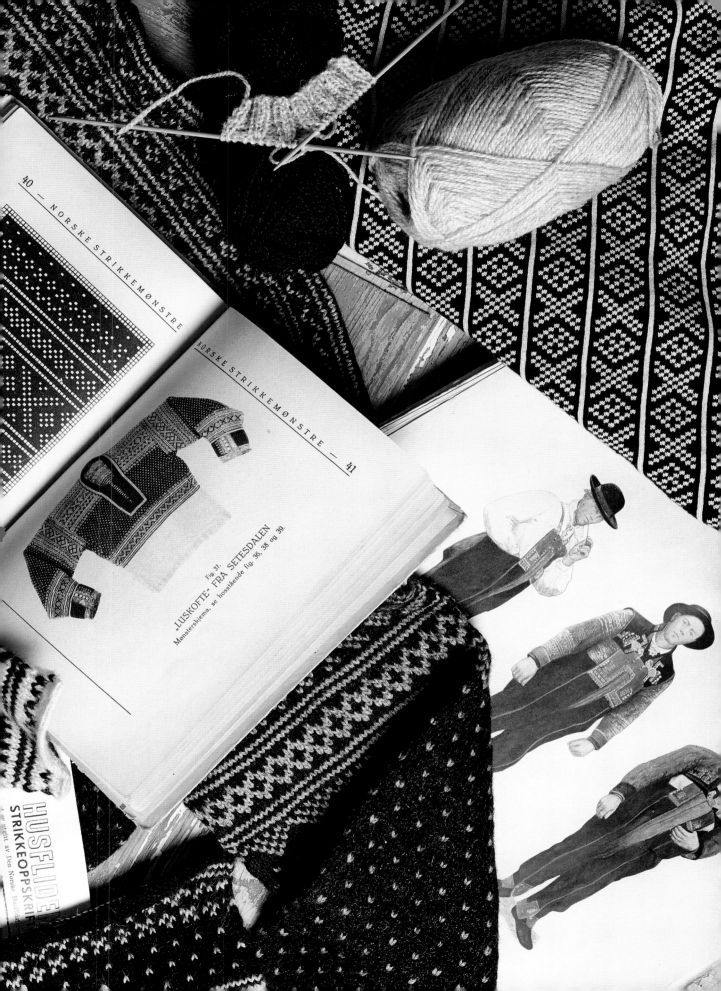

Fig. 37.
"LUSKOFTE" FRA SETESDALEN
Mønsterskjema, se hosstående fig. 36, 38 og 39.

HUSFLIDE
STRIKKEOPPSKRIF
er utgitt av Den Norske Husflidsfore

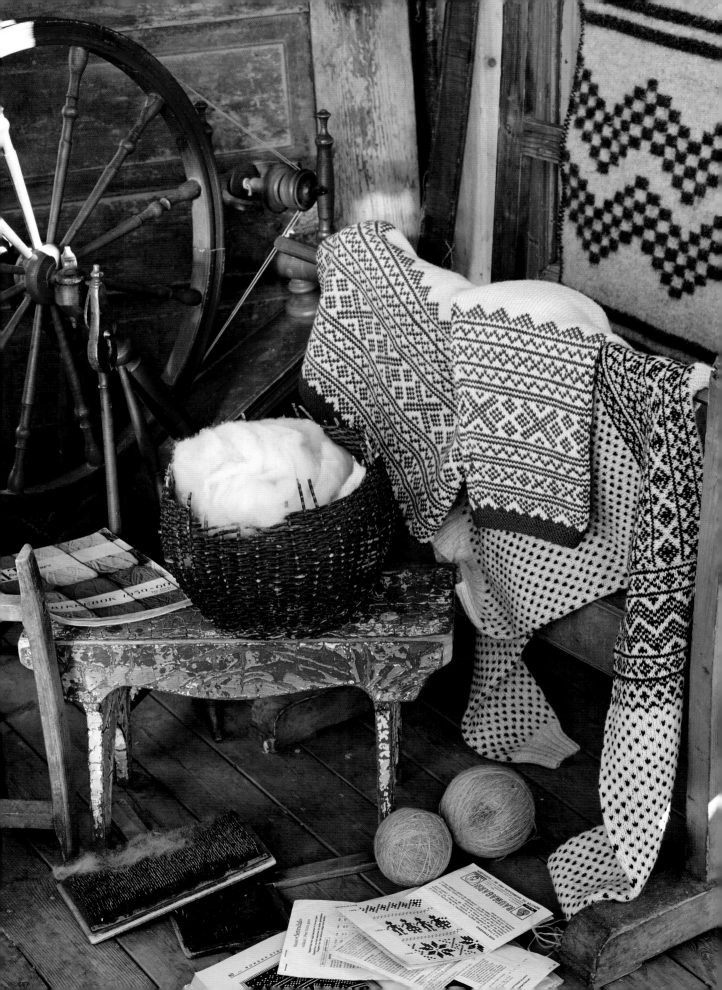

TRADITION

The traditional Setesdal sweater was originally a men's garment. It was black with white pattern motifs and white lice.

In Gert M. Høye's book, *Social Medicine Research in Valle, Setesdal* (1941), we found three pictures that show various men in Setesdal. All are wearing Setesdal sweaters. The most interesting aspect of these sweaters is the placement of the pattern panels, which is somewhat different from their placement on today's Setesdal sweaters.

The pattern panels on the body were narrower and almost comparable to the yoke on a sewn garment, such as men's shirts or a *buserull* (a cotton work shirt traditionally worn by farmers over a thick wool sweater. A *buserull* typically had long sleeves, was buttoned down with 4 buttons, and had very thin vertical stripes in dark blue or red). Newer sweaters are heavily embellished with pattern borders so wide that they go below the armhole. The cross and ring is also less dominant on the original sweaters. The zigzag border is larger and placed at the top of the sleeves, often as a double band. All of the sweaters feature lice for an extra layer of stranded yarn, which made the sweater warmer than one with the body knitted only in plain stockinette.

When Risen came home, he asked whether they would have the wedding soon. "Yes, I have thought about it," said the girl, "but there is so much wool here and we need to spin it first. I'll fill up a bag with wool to take to your mother when you go home to her tomorrow evening since she is so good at spinning," she said.

"Risen and the Three Sisters"—Johannes Skar, *Gamalt or Setesdal III* [Old Ways in Setesdal]

CHAPTER 3

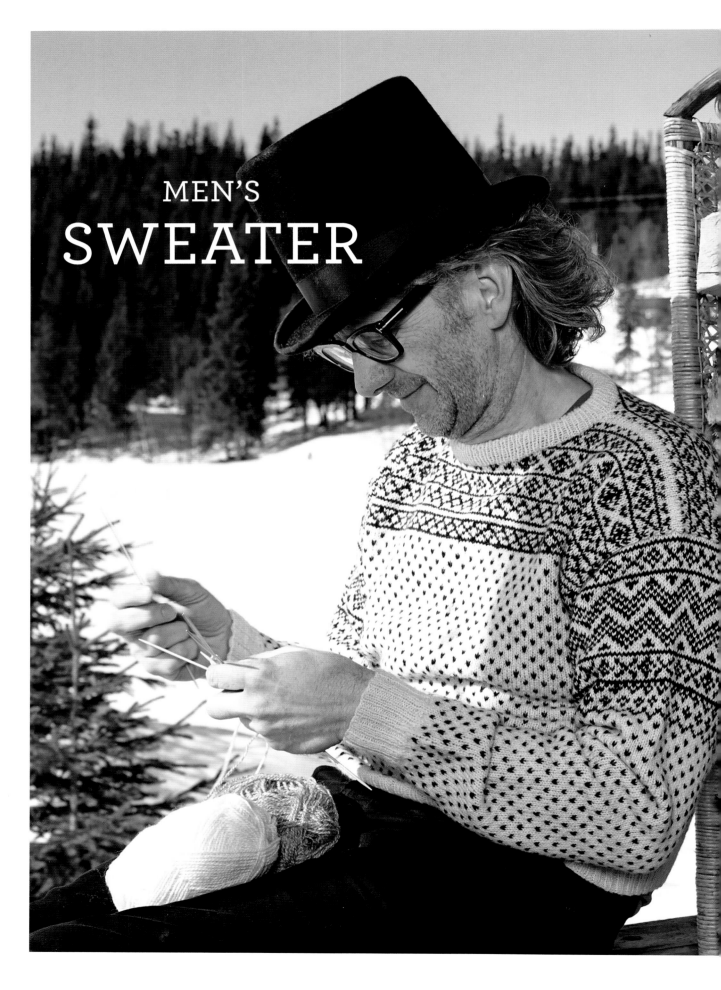

MEN'S
SWEATER

This sweater was inspired by pictures Arne took of two different Setesdal sweaters he found in an attic at Henriksentunet in Bykle. The sweater features typical Setesdal motifs, but the pattern panels are narrow, as they were on the old sweaters. We have also reversed the colors, so that white is the background color and the lice and patterns are black.

The body of the sweater is knitted around in one piece. After you've finished knitting, you will cut openings for the armholes and neck.

SIZES
S (M, M/L, L, XL)

FINISHED MEASUREMENTS
Chest: 39½ (42¼, 45¼, 48½, 51¼) in / 100 (107, 115, 123, 130) cm
Total length: 23¾ (23¾, 24½, 25¼, 26) in / 60 (60, 62, 64, 66) cm
Sleeve length: 21 (21¼, 21¼, 22, 22¾) in / 53 (54, 54, 56, 58) cm

MATERIALS
Yarn: (CYCA #1), Rauma Finullgarn, 100% wool (191 yd/175 m / 50 g)
Yarn Amounts:
Color 1: White 401 (MC), 350 (350, 400, 400, 450) g
Color 2: Black 410 (CC), 150 (150, 150, 200, 200) g

Needles: U.S. sizes 1-2 and 2-3 / 2.5 and 3 mm: circulars and set of 4 or 5 dpn

Gauge: 26 sts and 33 rounds in stockinette on larger needles = 4 x 4 in / 10 x 10 cm.
Adjust needle sizes to obtain correct gauge if necessary.

Arne's fine hat is early 20th century. We bought it at an antiques shop in Mexico City many years ago. It goes perfectly with the black and white sweaters and reminds us of old traditional pictures from Setesdal.

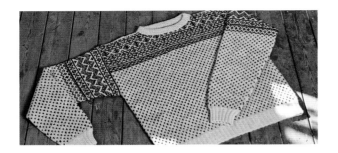

BODY

With smaller size circular and MC, CO 260 (280, 300, 320, 340) sts. Join, being careful not to twist cast-on row. Place marker for beginning of round. Work around in k2, p2 ribbing for 2½ in / 6 cm. Change to larger size circular and work lice pattern, following Chart 1. Begin at the arrow for your size. Continue in lice pattern until piece is approx. 18¼ (18¼, 19, 19¾, 19¾) in / 46 (46, 48, 50, 50) cm long and you've worked 2 single color rounds after the last rnd with lice.

Now work 1 repeat in length of pattern, following Chart 2, beginning at arrow for your size. When pattern is complete, divide sts of front and back onto separate strands of yarn with 130 (140, 150, 160, 170) sts on each strand. Set body aside.

SLEEVES

With smaller dpn and MC, CO 56 (56, 60, 60, 64) sts. Join, being careful not to twist cast-on row. Work around in k2, p2 ribbing for 2½ in / 6 cm. On the last rnd, increase evenly spaced around to 61 (61, 63, 65, 67) sts. Change to larger dpn and work lice pattern, following Chart 1. Count the stitches so that the X on the chart is the center of the sleeve. *At the same time* as beginning lice, every ⅝ in / 1.5 cm, increase 2 sts at center of underarm until there are a total of 115 (119, 123, 127, 131) sts. Increase as follows: K1, M1R, knit until 1 st rem, M1L, k1. Work new sts into pattern. Continue in lice pattern until sleeve is approx. 15 (15½, 15½, 16¼, 17) in / 38 (39, 39, 41, 43) cm long and you've worked 2 single color rnds after the last lice rnd.

Now work 1 repeat of pattern, following Chart 3, making sure that the X on the chart matches center of sleeve.

Turn sleeve inside out and, with MC, work ¾ in / 2 cm in stockinette for the facing. *At the same time*, increase 2 sts at underarm on every other rnd. BO loosely.

Sleeve and Neck Finishing

Lay the sleeve flat and measure the width of the sleeve just below the facing. Mark the sleeve width at each side of the body down from the shoulder. The first and last sts of the front and back are the side sts. Machine-stitch 2 lines down between the markers and then carefully cut the armholes open between the stitch lines.

Mark the neck opening by hand basting the neckline. The neck opening should be 8 (8¼, 8¼, 8¾, 8¾) in / 20 (21, 21, 22, 22) cm wide, 2¾ in / 7 cm deep at center front, and ¾ in / 2 cm deep at center back. Round the neckline smoothly, making sure that the patterns match on both sides. Machine-stitch 2 lines inside the basting threads and then cut away excess fabric above stitching, leaving a small seam allowance. Join shoulders either with Kitchener stitch or 3-needle bind-off.

NECKBAND

With smaller size circular and MC, pick up and knit approx. 124 (128, 128, 132, 132) sts around neck. Work around in k1, p1 ribbing for 2½ in / 6 cm. BO loosely. Fold neckband and sew down by hand on WS.

Attach sleeves. Fold facing over cut edges and sew down on WS.

Chart 1—Lice Pattern for Body and Sleeves

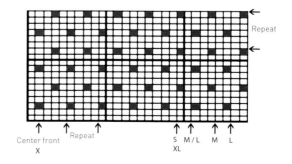

Chart 2—Pattern Repeat for the Body

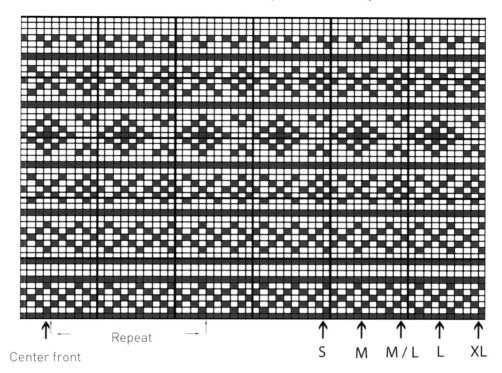

Center front

←— Repeat —→

S M M/L L XL

Chart 3—Pattern Repeat for Top of Sleeves

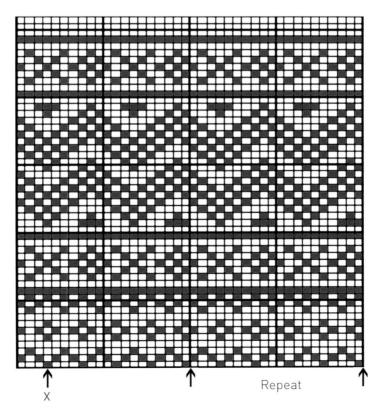

X Repeat

This is a lovely and feminine women's sweater that we decided to knit in Mitu, Rauma's alpaca/wool blend yarn. The sweater looks rectangular when it is laid out flat but will drape quite nicely once you put it on. We were also inspired by the white lower edge of traditional Setesdal sweaters but decided to pass on that idea. We reversed the tradition and placed the pattern at the bottom and the white section at the top of the body and sleeves.

WOMEN'S SWEATER
WITH WIDE PATTERN BORDERS

SIZES
S (M, L, XL)

FINISHED MEASUREMENTS
Chest: 37 (40¼, 43, 47¼) in / 94 (102, 109, 120) cm
Total length: 22½ (22½, 22¾, 22¾) in / 57 (57, 58, 58) cm
Sleeve length: 17¼ (17¼, 17¾, 18¼) in / 44 (44, 45, 46) cm

MATERIALS
Yarn: (CYCA #3), Rauma Mitu, 50% superfine alpaca and 50% wool yarn (109 yd/100 m / 50 g)
Yarn Amounts:
Color 1: White SFN 10 (MC) 500 (500, 550, 600) g
Color 2: Green 5340 (CC) 150 (200, 200, 200) g

Needles: U.S. sizes 2-3 and 4 / 3 and 3.5 mm: circulars and set of 4 or 5 dpn

Gauge: 22 sts and 28 rounds in stockinette on larger needles = 4 x 4 in / 10 x 10 cm.
Adjust needle sizes to obtain correct gauge if necessary.

BODY
With CC and smaller size circular, CO 208 (224, 240, 264) sts. Join, being careful not to twist cast-on row. Place marker for beginning of round. Work garter st in the rnd: alternate 1 purl rnd and 1 knit rnd for ¾ in / 2 cm = 5 ridges. Place a marker at each side with 104 (112, 120, 132) sts each for front and back.

Change to larger size circular and work 1 lengthwise repeat of pattern, following Chart 1. Begin at arrow for your size and work to side marker = front. Repeat for the back. After completing charted pattern, continue around in stockinette with MC for 4 rnds and, on the last rnd, dec 1 st each on front and back = 103 (111, 119, 131) sts rem on each part. The sweater should now be approx. 11½ in / 29 cm long. Begin working front and back separately.

FRONT
Continue in stockinette, working back and forth. When armhole is 8¼ in / 21 cm long for all sizes, place the center 19 sts on a holder for neck. Work each shoulder separately. Shape neck by binding off at neck edge on every other row: BO 3 sts 5 times and 1 st 2 times = 25 (29, 33, 39) sts rem for each shoulder.

Continue without further shaping until armhole depth measures 11 (11, 11½, 11½) in / 28 (28, 29, 29) cm. Place shoulder sts on a holder. Work other side the same way, reversing shaping.

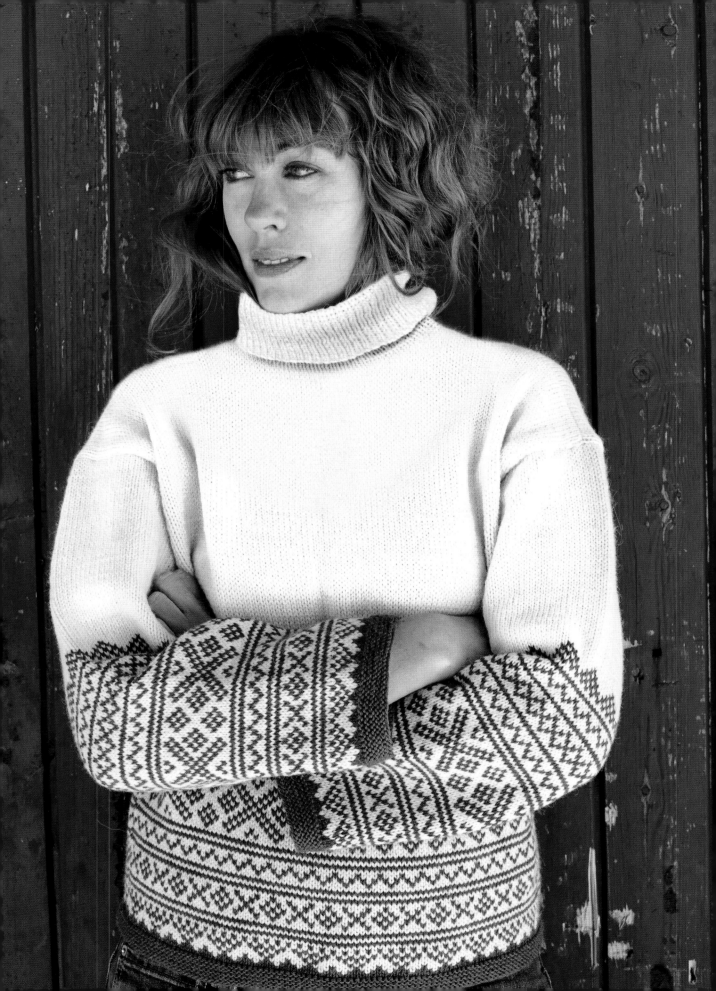

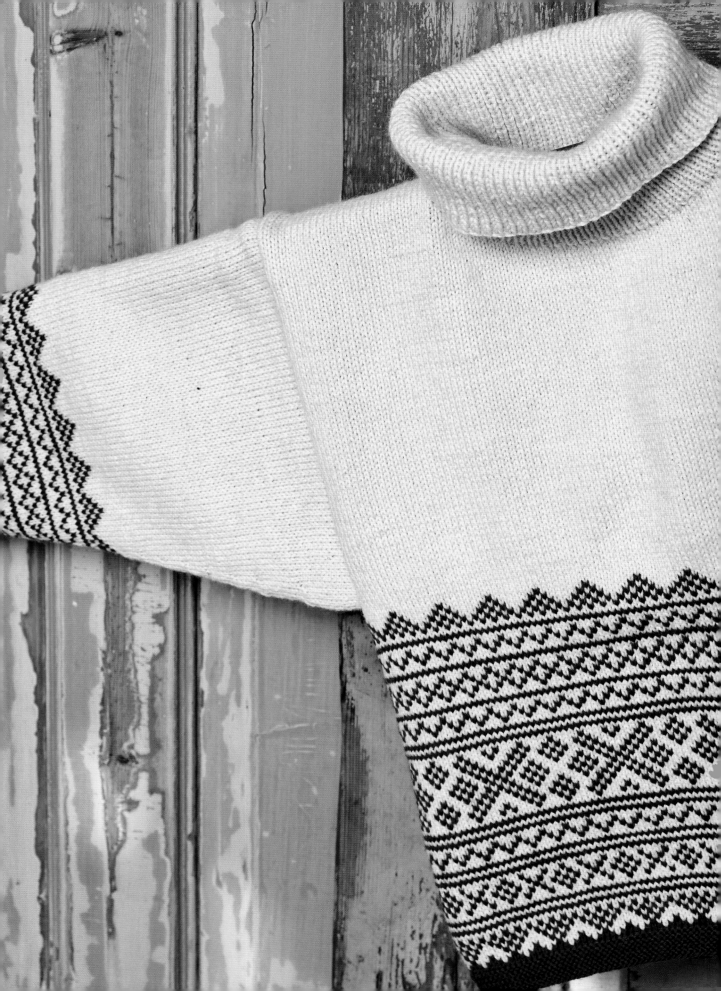

BACK

Work back and forth in stockinette. When armhole measures 10¼ in / 26 cm for all sizes, place the center 47 sts on a holder for back neck. Work each shoulder separately. At neck edge, on every other row, BO 2 sts 1 time and 1 st 1 time = 25 (29, 33, 39) sts rem for each shoulder.

Continue without further shaping until armhole measures 11 (11, 11½, 11½) in / 28 (28, 29, 29) cm. Place shoulder sts on a holder. Work other side the same way, reversing shaping.

SLEEVES

With CC and smaller size dpn, CO 79 (79, 83, 83) sts. Join, being careful not to twist cast-on row. Work garter stitch edging as for body. Change to larger size dpn. Work 1 lengthwise repeat of pattern, following Chart 1. Count out stitches to make sure that the X on the chart is at center of sleeve.

At the same time, every ¾ in / 2 cm, increase 2 sts at center of underarm until there are a total of 123 (123, 127, 127) sts. Increase as follows: K1, M1R, knit until 1 st rem, M1L, k1. Work new sts into pattern. When pattern is complete, continue in stockinette with MC until sleeve is 17¼ (17¼, 17¾, 18¼) in / 44 (44, 45, 46) cm long. BO.

FINISHING

Join shoulders either with Kitchener st or 3-needle bind-off. Sew in sleeves by hand.

Neckband

With MC and smaller size circular, pick up and knit approx. 132 (132, 132, 132) sts around neck. Work around in k1, p1 ribbing for 7 in / 18 cm. BO, making sure that bind-off is not too tight. Fold neckband forward for turtleneck.

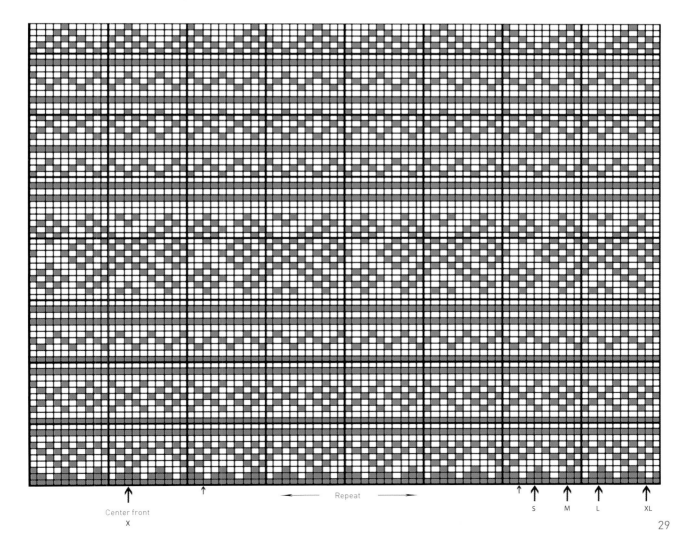

Center front
X

Repeat

S M L XL

We found the inspiration for this design with a vertical cross and ring motif in a pattern booklet called *Four Easy Stocking Patterns*, from the handcraft shop Husfliden in Bergen, Norway. The original pattern was designed to be worked in 3-ply "farmer's" yarn and had small flowers between the crosses. We changed the flowers to rings.

PILLOW WITH
STOCKING PATTERN

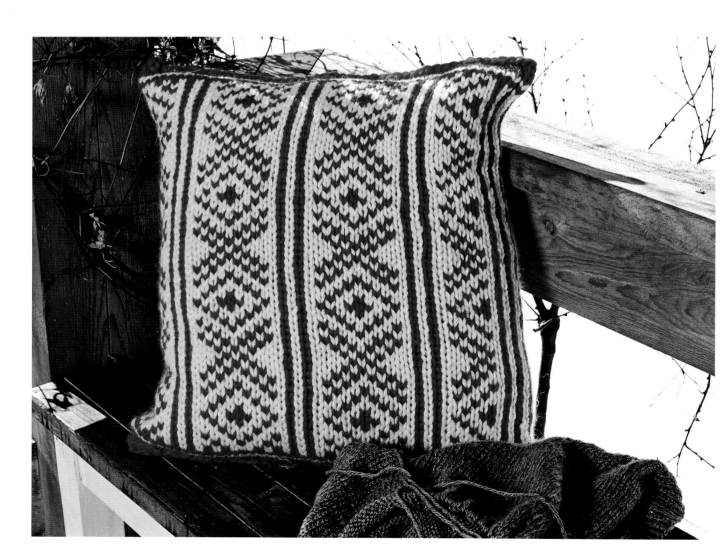

When we worked in the fashion industry, we combined this pattern with another old Norwegian pattern on one of our sweaters. These Norwegian patterns became very popular in other countries not only because they were Norwegian but also because we used a Merino wool/alpaca blend yarn. When the style returned to Norway 2-3 years later, we had already stopped producing ready-made knitwear.

The pillow is worked with a doubled strand of yarn. You can knit from one ball of yarn by pulling out strands from the inside and outside of the ball and holding them together, or holding strands from 2 balls of yarn together.

FINISHED MEASUREMENTS
17¾ x 17¾ in / 45 x 45 cm

MATERIALS
Yarn: (CYCA #4), Rauma Vamse, 100% wool (91 yd/83 m / 50 g)
Yarn Amounts:
Color 1: White V01, 200 g
Color 2: Red V35, 200 g

NOTE: Hold 2 strands together throughout.

Needles: U.S. size 10½ / 6.5 mm: 32 in / 80 cm circular

Notions: Pillow form, 24 x 24 in / 60 x 60 cm. The finished pillow measures approx. 17¾ x 17¾ in / 45 x 45 cm, but we used a larger pillow form since a form the same size as the pillow cover flattens out with use. The larger form helps the pillow keep its shape and plumpness longer.

Gauge: 10 sts and 14 rows = 4 x 4 in / 10 x 10 cm. Adjust needle size to obtain correct gauge if necessary.

PILLOW
Holding 2 strands of Color 2 together, CO 100 sts. Join, being careful not to twist cast-on row. Place marker for beginning of round. Work (P1, k49) 2 times. The cast-on row + the first row worked correspond to the first 2 rows of the chart. Continue following the chart, working knit over knit and purl over purl, until 1 row remains on chart. BO with Color 2.

FINISHING
Weave in ends neatly on WS and then steam press pillow cover under a damp pressing cloth. With Color 2, seam one end of the pillow, making sure that the purl stitches are at the sides. Insert pillow form. Use Color 2 to seam the other end of the pillow and weave in remaining ends.

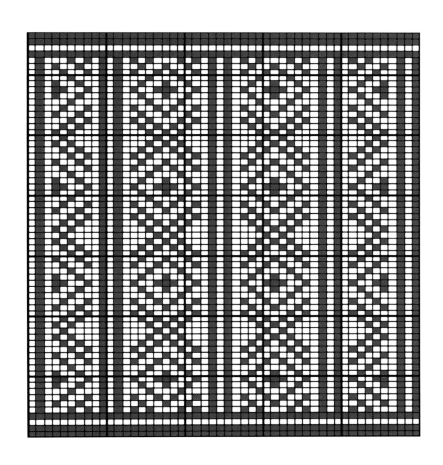

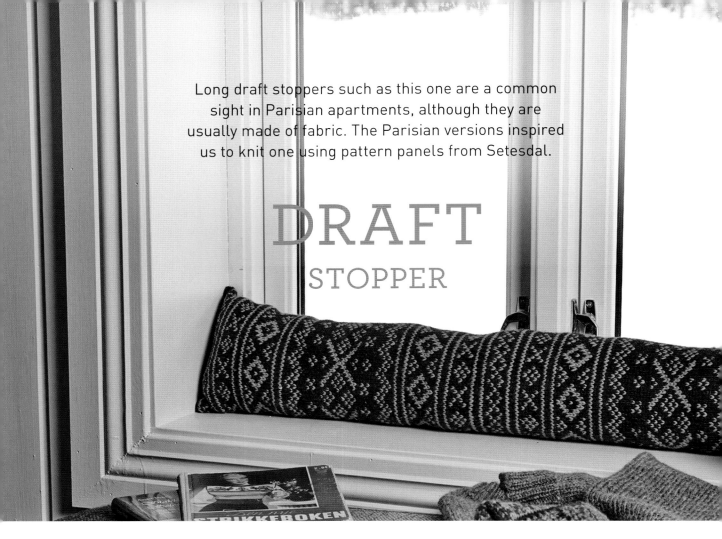

Long draft stoppers such as this one are a common sight in Parisian apartments, although they are usually made of fabric. The Parisian versions inspired us to knit one using pattern panels from Setesdal.

DRAFT
STOPPER

FINISHED MEASUREMENTS

15 in / 38 cm diameter x 43¼ in / 110 cm long. Work the panels as many times as you need so the draft stopper will be the right length for your window or door.

MATERIALS

Yarn: (CYCA #4), Rauma Vamse, 100% wool (91 yd/83 m / 50 g)
Yarn Amounts:
Color 1: Brown V64, 150 g
Color 2: Blue V50, 100 g

Needles: U.S. size 8 / 5 mm: 16 in / 40 cm circular

Notions: Fiber Fill from Coats

Gauge: 19 sts and 23 rows = 4 x 4 in / 10 x 10 cm. Adjust needle size to obtain correct gauge if necessary.

DRAFT STOPPER

With short circular and Color 1, CO 72 sts; join, being careful not to twist cast-on row. Place marker for beginning of round. Work around following the chart, repeating the chart twice across.

NOTE: The first row of the chart = cast-on row.

The pattern repeat is marked off by arrows; work repeat until draft stopper is desired length. End with 1 rnd using Color 1 and then BO knitwise with Color 1.

FINISHING

Weave in ends neatly on WS and then steam press draft stopper cover under a damp pressing cloth. With Color 2, seam one end of the draft stopper. Make a pillow form to insert, or stuff with fiber fill, and then seam the other end of draft stopper.

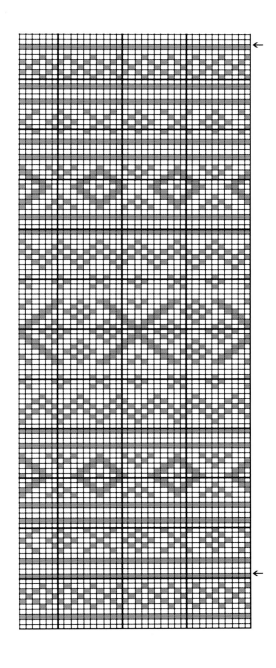

"Many a black sheep can have a white lamb."

Old folk saying from Setesdal

Såve used to be a common men's name in Setesdal, and we decided it was an appropriate name for this bear. The idea for this delightful animal came from a Japanese magazine. The original that we saw was made in patchwork with strips of fabric from old Japanese kimonos.

TEDDY BEAR

Our version is made with Setesdal motifs.

FINISHED MEASUREMENTS
Our bear is approx. 15¾ in / 40 cm long, but the length will vary from knitter to knitter depending on gauge and how firmly you stuff the bear.

MATERIALS
Yarn: (CYCA #2), Rauma Finullgarn, 100% pure new wool (191 yd/175 m / 50 g)
Yarn Amounts:
Color 1: White 401, 100 g
Color 2: Gray 404, 50 g
Color 3: Pink 4087, 50 g
small amount of black to embroider nose, mouth and eyes

Needles: U.S. size 1-2 / 2.5 mm: 16 in / 40 cm circular and set of 5 dpn

Notions: Wool batting for fill and 2 safety pins

Gauge: 30 sts and 36 rows = 4 x 4 in / 10 x 10 cm. Adjust needle size to obtain correct gauge if necessary.

LEGS
With Color 1 and dpn, CO 12 sts, join, and divide evenly over 4 dpn = 3 sts per needle. Work around in pattern, following Chart 1; the bottom row of the chart = cast-on row. As you work, increase as follows:
Rnd 1: K12.
Rnd 2: Work (k2, M1, k1) around.
Rnd 3: K16.
Rnd 4: Work (k1, M1, k2, M1, k1) around.
Rnd 5: K24.
Rnd 6: Work (k1, M1, k4, M1, k1) around.
Rnd 7: K32.
Rnd 8: (K1, M1, k6, M1, k1) around.
Rnd 9: K40.
Pull beginning tail tight and close hole at bottom of foot.
Rnds 10-12: K40.
Rnd 13: K1, M1, k38, M1, k1.
Rnds 14-17: K42.
Rnd 18: K1, M1, k40, M1, k1.
Rnds 19-22: K44.
Rnd 23: K1, M1, k42, M1, k1.
Rnds 24-35: K46.
Rnd 36: K1, M1, k44, M1, k1.

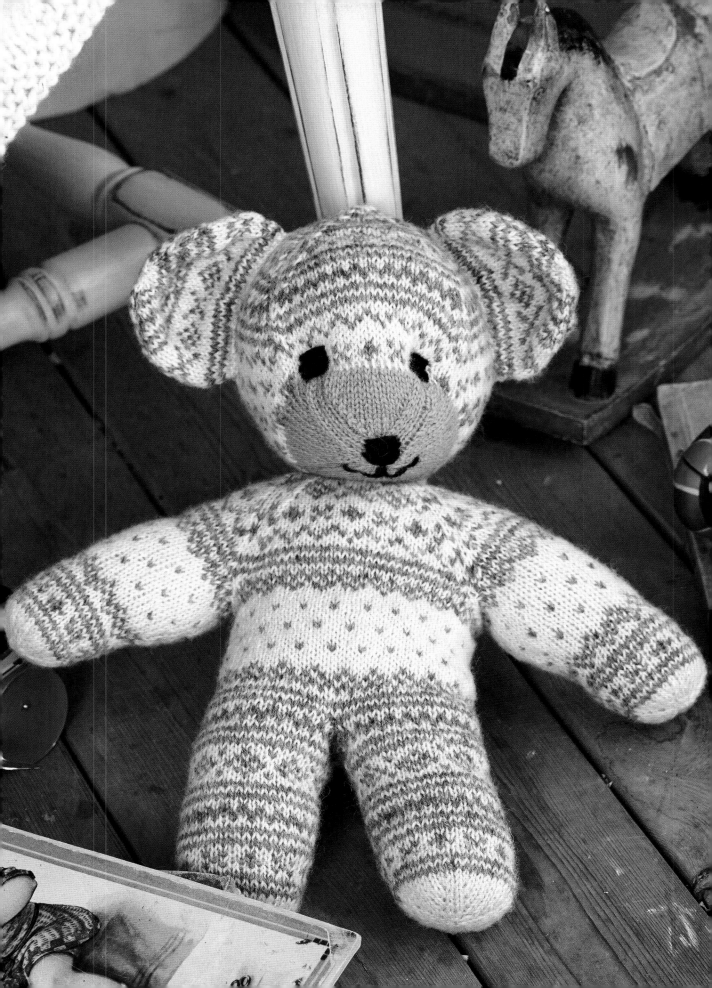

Rnd 37: K48.
Rnd 38: K1, M1, k46, M1, k1.
Rnd 39: K50.
Rnd 40: K1, M1, k48, M1, k1.
Rnds 41-43: K52.
Rnd 44: BO 5, k42 (including last st after bind-off), BO 5.
Divide sts onto 2 dpn with 21 sts on each needle. Make the second leg the same way.

STOMACH

Now knit the legs together. Hold the legs with the bound-off sts facing each other, turned towards the center. Fasten them together with a safety pin = 84 sts total. Beginning on one side of one leg, work 1 rnd with Color 1 = 1st rnd of Chart 2. The stomach begins at this point. Now work in pattern, following the chart. On Rnd 4, increase as follows on dpn 1 and 3:
K1, M1, knit to end of needle = 86 sts. Continue in pattern, following Chart 2. The round starts at the side. On the last round, decrease as follows: *BO 5, k34 (including the last st after bind-off), BO 4*; rep from * to * once more. Place sts for front and back each on a separate dpn = 34 sts per needle.

Seam the groin and weave in ends neatly on WS.

ARMS

With Color 1 and dpn, CO 12 sts, join, and divide evenly over 4 dpn = 3 sts per needle. Work around in pattern, following Chart 3; the bottom row of the chart = cast-on row. As you work, increase as follows:
Rnd 1: K12.
Rnd 2: Work (k2, M1, k1) around.
Rnd 3: K16.
Rnd 4: Work (k1, M1, k2, M1, k1) around.
Rnd 5: K24.
Rnd 6: Work (k1, M1, k4, M1, k1) around.
Rnd 7: K32.
Pull beginning tail tight and close hole at end of arm.
Rnds 8-9: K32.
Rnd 10: K1, M1, k30, M1, k1.
Rnds 11-13: K34.

Rnd 14: K1, M1, k32, M1, k1.
Rnds 15-17: K36.
Rnd 18: K1, M1, k34, M1, k1.
Rnds 19-21: K38.
Rnd 22: K1, M1, k36, M1, k1.
Rnds 23-25: K40.
Rnd 26: K1, M1, k38, M1, k1.
Rnds 27-29: K42.
Rnd 30: K1, M1, k40, M1, k1.
Rnds 31-43: K44.
Rnd 44: BO 5, k34 (including last st of bind-off), BO 5.
Divide sts onto 2 dpn with 17 sts per needle. Make the other arm the same way.

UPPER BODY

Join the arms and body as follows: Hold the bound-off edge of one arm against the corresponding edge on the body and fasten together with a safety pin. Do the same on the opposite side. Work in pattern, following Chart 4 with sts of each arm divided onto 2 dpn until you've bound off enough sts so that each arm fits onto 1 dpn. Shape the raglan as follows:
Begin with the 1st needle of body, which is the front of the bear:
Rnd 1: K136.
Rnd 2: K136.
Rnd 3: (K1, k2tog, k28, k2tog, k1) around.
Rnd 4: K128.
Rnd 5: (K1, k2tog, k26, k2tog, k1) around.
Rnd 6: K120.
Rnd 7: (K1, k2tog, k24, k2tog, k1) around.
Rnd 8: K112.
Rnd 9: (K1, k2tog, k22, k2tog, k1) around.
Rnd 10: K104.
Rnd 11: (K1, k2tog, k20, k2tog, k1) around.
Rnd 12: K96.
Weave in ends on WS of bear and seam underarms.
Rnd 13: (K1, k2tog, k18, k2tog, k1) around.
Rnd 14: K88.
Rnd 15: (K1, k2tog, k16, k2tog, k1) around.
Rnd 16: K80.
Rnd 17: (K1, k2tog, k14, k2tog, k1) around.
Rnd 18: K72.
Rnd 19: (K1, k2tog, k12, k2tog, k1) around.

Chart 1—Legs

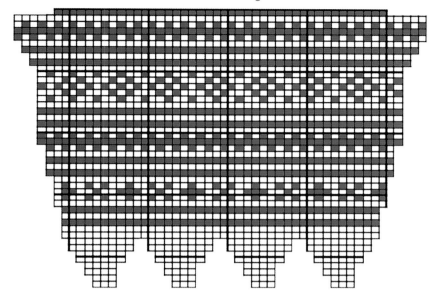

Chart 2—Stomach

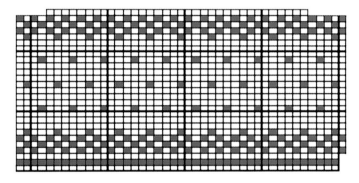

Chart 3—Arms

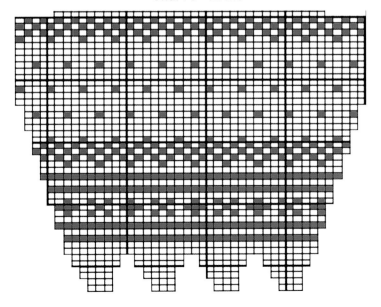

Rnd 20: K64.
Rnd 21: (K1, k2tog, k10, k2tog, k1) around.
Rnd 22: K56.
Rnd 23: (K1, k2tog, k8, k2tog, k1) around.
Rnd 24: K48.
Rnd 25: (K1, k2tog, k6, k2tog, k1) around.
Rnd 26: K40.
Rnd 27: (K1, k2tog, k4, k2tog, k1) around.
Rnd 28: K32.

HEAD
Rnd 1: K32.
Rnd 2: K32.
Rnd 3: (K1, M1, k6, M1, k1) around.
Rnd 4: K40.
Rnd 5: (K1, M1, k8, M1, k1) around.
Rnd 6: K48.
Rnd 7: (K1, M1, k10, M1, k1) around.
Rnd 8: K56.
Now work the opening for the snout, following the chart from X to X. Continue in stockinette as shown on the chart but place the 14 sts on ndl 1 (front) on a holder while you work back and forth over the rem 42 sts.
Row 9: P42.
Row 10: (K1, M1, k12, M1, k1) across.
Row 11: P48.
Row 12: (K1, M1, k14, M1, k1) across.
Row 13: P54.
Row 14: (K1, M1, k16, M1, k1) across.
Row 15: P60.
Row 16: (K1, M1, k18, M1, k1) across.
Row 17: P66.
Row 18: (K1, M1, k20, M1, k1) across.
Row 19: P72.
Row 20: (K1, M1, k22, M1, k1) across.
Row 21: P78.
Row 22: (K1, M1, k24, M1, k1) across.
Row 23: P84.

Now return to knitting around over 4 dpn as follows:
Work across ndls 2-4: (K1, M1, k26, M1, k1) across each ndl. CO 30 sts with a new ndl 1 over the gap for the snout.

Rnd 25: K120.
Rnd 26: (K1, M1, k28, M1, k1) around.
Rnds 27-35: K128.
Rnd 36: (K1, k2tog, k26, k2tog, k1) around.
Rnd 37: K120.
Rnd 38: (K1, k2tog, k24, k2tog, k1) around.
Rnd 39: K112.
Rnd 40: (K1, k2tog, k22, k2tog, k1) around.
Rnd 41: K104.
Rnd 42: (K1, k2tog, k20, k2tog, k1) around.
Rnd 43: K96.
Rnd 44: (K1, k2tog, k18, k2tog, k1) around.
Rnd 45: K88.
Rnd 46: (K1, k2tog, k16, k2tog, k1) around.
Rnd 47: K80.
Rnd 48: (K1, k2tog, k14, k2tog, k1) around.
Rnd 49: K72.
Rnd 50: (K1, k2tog, k12, k2tog, k1) around.
Rnd 51: K64.
Rnd 52: (K1, k2tog, k10, k2tog, k1) around.
Rnd 53: K56.
Rnd 54: (K1, k2tog, k8, k2tog, k1) around.
Rnd 55: K48.
Rnd 56: (K1, k2tog, k6, k2tog, k1) around.
Rnd 57: K40.
Rnd 58: (K1, k2tog, k4, k2tog, k1) around.
Rnd 59: K32.
Rnd 60: (K1, k2tog, k2, k2tog, k1) around.
Rnd 61: K24.
Rnd 62: (K1, k2tog, k2tog, k1) around.
Rnd 63: K16.
Rnd 64: (K1, k2tog, k1) around.
Cut yarn and draw through the rem 12 sts. Tighten and close hole at top of head. Weave in all ends neatly on WS. Fill body with wool before you knit the snout.

SNOUT
With Color 1, pick up and knit the 30 sts above the snout opening onto 1 dpn. Place the held 14 sts for the lower part of the snout onto another dpn. With a separate dpn for each, pick up and knit 16 sts on each side of the snout. Now divide the sts so there are 19 sts on each dpn. Change to Color 3 and shape snout as follows:

Rnd 1: K76.
Rnd 2: (K1, k2tog, k13, k2tog, k1) around.
Rnd 3: K68.
Rnd 4: (K1, k2tog, k11, k2tog, k1) around.
Rnd 5: K60.
Before continuing, weave in yarn tail for Color 3.
Rnd 6: (K1, k2tog, k9, k2tog, k1) around.
Rnd 7: K52.
Rnd 8: (K1, k2tog, k7, k2tog, k1) around.
Rnd 9: K44.
Rnd 10: (K1, k2tog, k5, k2tog, k1) around.
Rnd 11: K36.
Rnd 12: (K1, k2tog, k3, k2tog, k1) around.
Rnd 13: K28.
Rnd 14: (K1, k2tog, k1, k2tog, k1) around.
Rnd 15: K20.
Rnd 16: (K1, k2tog, k2) around.
Rnd 17: K16.
Rnd 18: (K1, k2tog, k1) around.

Cut yarn and draw end through rem 12 sts. Fill head with wool and then tighten yarn at tip of snout. Draw end through sts again and then weave in yarn tail through WS. Knit the ears.

EARS

With Color 1, CO 12 sts. Join and divide evenly onto 4 dpn = 3 sts per needle.
Work in pattern, following Chart 5. *At the same time*, shape ears as described below. The first row of the chart = cast-on row.
Rnd 1: K12.
Rnd 2: (K1, M1, k1, M1, k1) around.
Rnd 3: 20.
Rnd 4: (K1, M1, k3, M1, k1) around.
Rnd 5: K28.
Rnd 6: (K1, M1, k5, M1, k1) around.
Rnd 7: K36.
Rnd 8: (K1, M1, k7, M1, k1) around.
Rnd 9: K44.
Rnd 10: (K1, M1, k9, M1, k1) around.
Rnd 11: K52.
Rnd 12: (K1, M1, k11, M1, k1) around.
Rnds 13-23: K60.
Rnd 24: (K1, k2tog, k9, k2tog, k1) around.
Rnd 25: K52.

Chart 4—Upper Body and Head

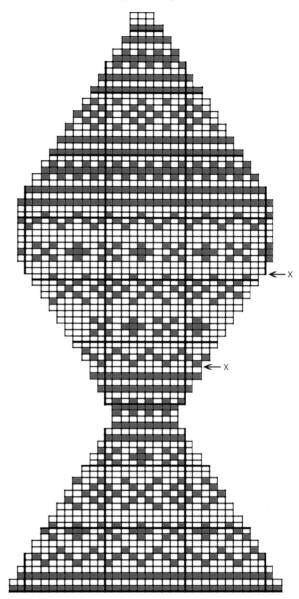

←x
←x

Rnd 26: (K1, k2tog, k7, k2tog, k1) around.
Rnd 27: K44.

BO and weave in ends on inside of each ear. Lay ears flat and then curve the bottom towards the snout and sew an ear securely to each side of the head. Sew down all around base of ear.

Embroidering the Face: Follow the pictures on page 41.

Chart 5—Ears

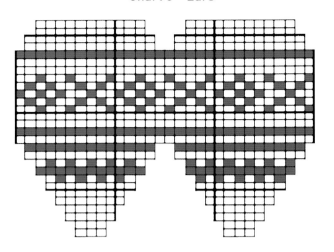

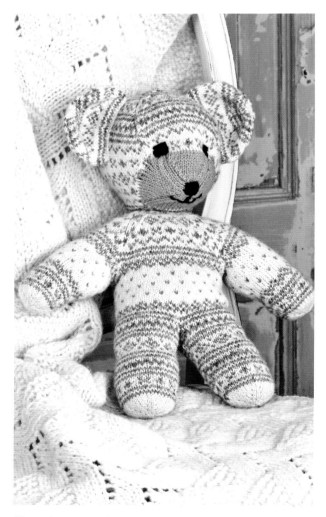

Shape the ears so they stand out smoothly. Sew them to the head on each side of the open end of ear.

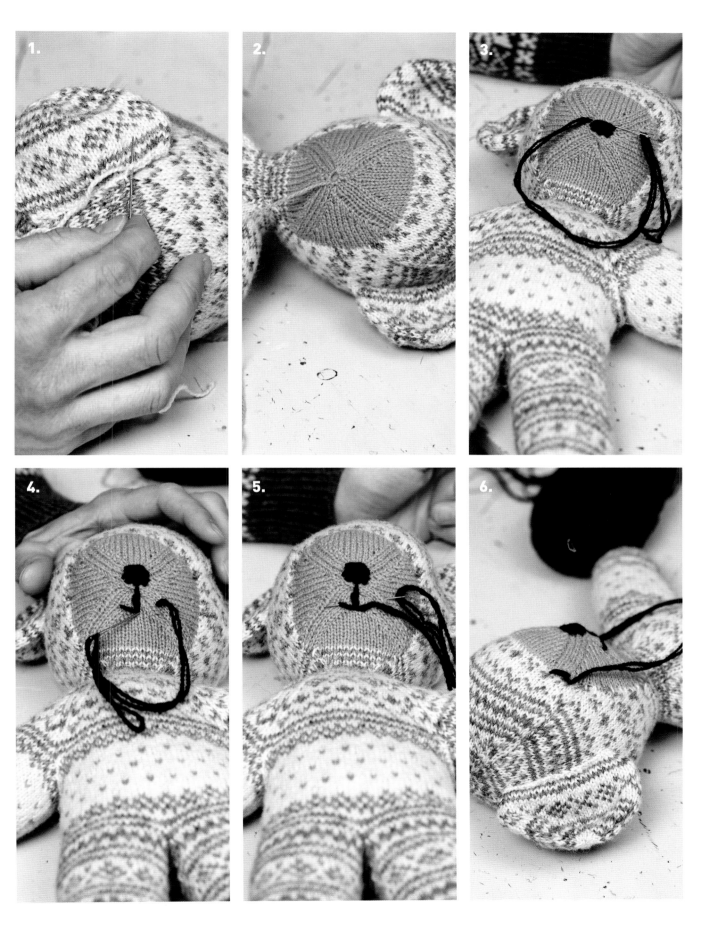

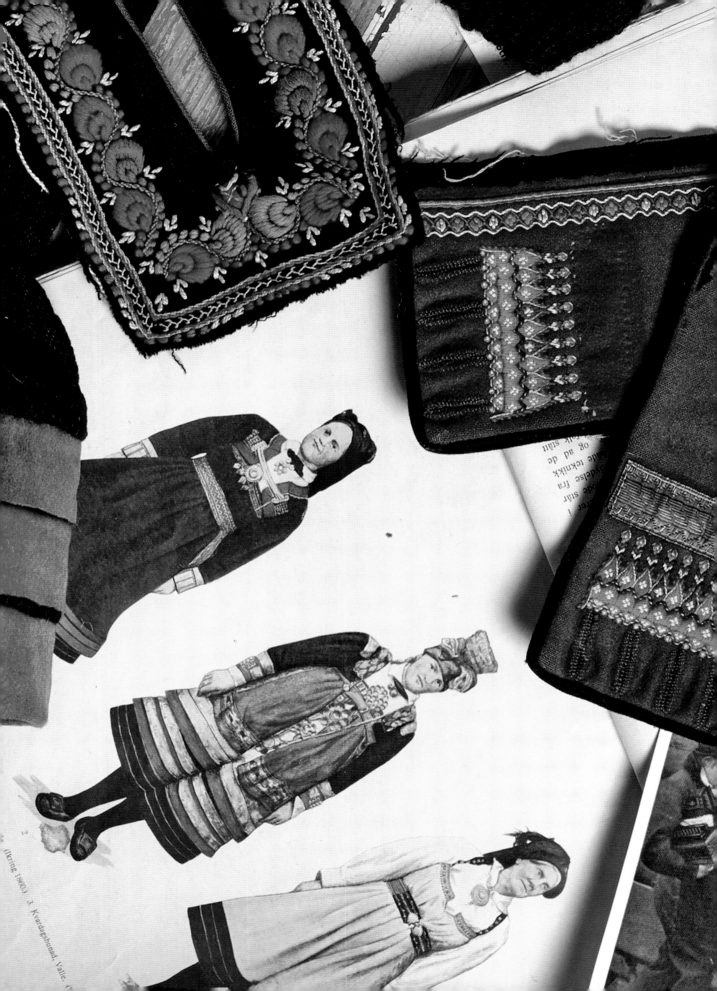

(Ikring 1860) 3. Kvardagsbunad, Valle (

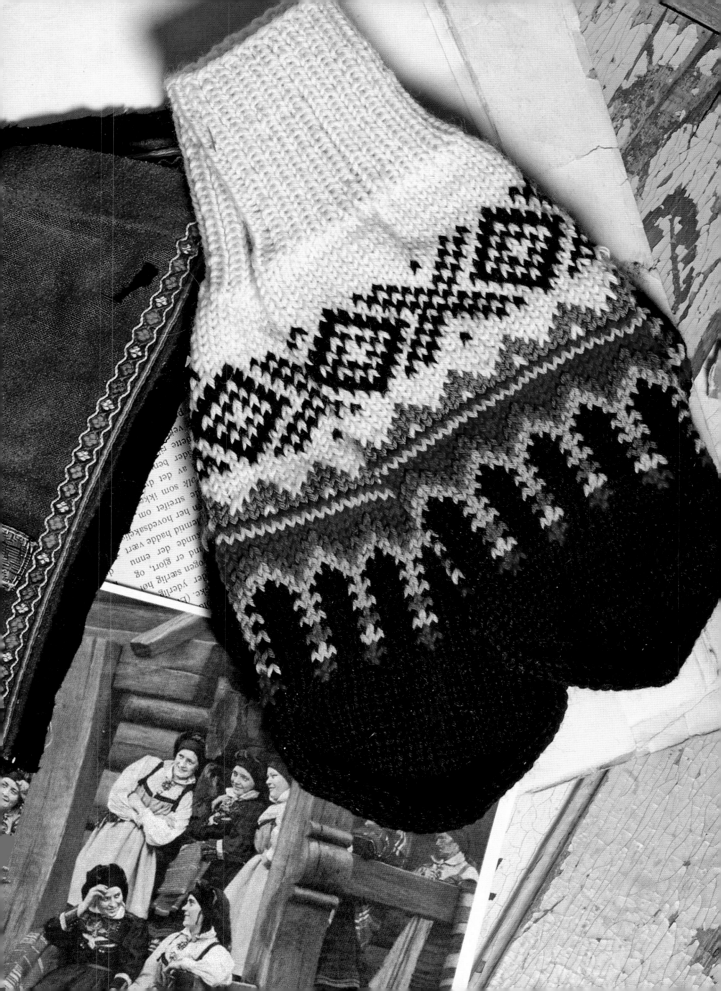

IDEN'S
OPPSKRIFTER
Den Norske Husflidsforening — Oslo

Damejakke
(Setesdalsjakke)
Meter nr. 25 B

EMBROIDERY

We've taken the inspiration for the projects in this chapter from *løyesaum*, a special type of Setesdal embroidery, as well as from other types of embroidery found on, for example, men's shirts worn with Setesdal folk costumes.

This border is called *endegatu* in Bykle and *klo* in Valle, but both of the Norwegian words refer to the embroidery motif called the Five Wise Virgins. The pictures on pages 42-43 show two old cuffs that we have. They were cut from an old *vadmal* sweater and have the same embroidery that was used on knitted sweaters.

We simplified the embroidery motifs and transformed them into knitting patterns. They work quite well for each end of this pillow. The colors on the pillow are more subdued than those on the accessories shown on page 48 and remind us more of the colors in the framed embroidery. You don't necessarily need to match your interior.

PILLOW
WITH *ENDEGATU* MOTIFS

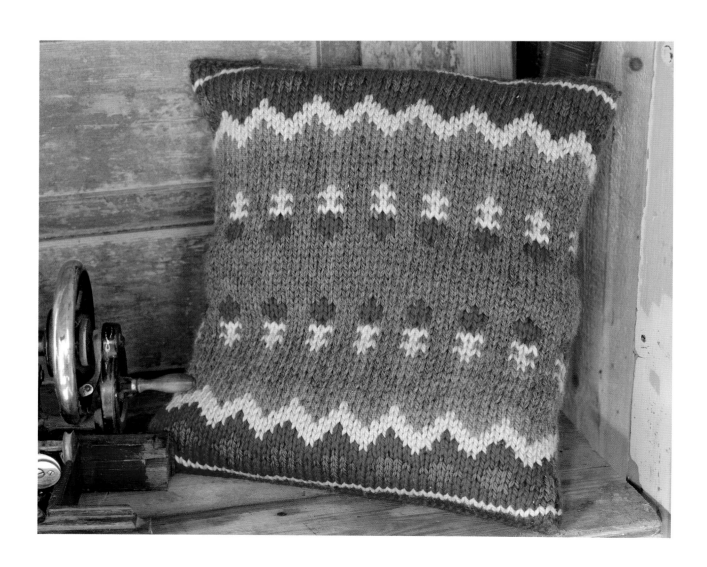

FINISHED MEASUREMENTS

17¾ x 17¾ in / 45 x 45 cm

MATERIALS

Yarn: (CYCA #4), Rauma Vamse, 100% wool
(91 yd/83 m / 50 g)
Yarn Amounts:
Color 1: Gray V13, 100 g
Color 2: Red V35, 100 g
Color 3: Yellow V20, 50 g
Color 4: Purple V65, 50 g
Color 5: Light Blue V49, 50 g
Color 6: Green V88, 50 g

NOTE: Hold 2 strands of yarn together throughout.

Needles: U.S. size 10½ / 6.5 mm: 32 in / 80 cm
circular

Notions: Pillow form, 24 x 24 in / 60 x 60 cm. The
finished pillow measures approx. 17¾ x 17¾ in / 45
x 45 cm, but we used a larger pillow form since a
form the same size as the pillow cover flattens out
with use. The larger form helps the pillow keep its
shape and plumpness longer.

Gauge: 10 sts and 14 rows = 4 x 4 in / 10 x 10 cm.
Adjust needle size to obtain correct gauge if neces-
sary.

PILLOW

With 2 strands of Color 2 held together, CO 100 sts.
Join, being careful not to twist cast-on row. Place
marker for beginning of round. Change to Color 3
and work (P1, k49) 2 times. The cast-on row + the
first row worked correspond to the first 2 rows of
the chart. Continue, following the chart and work-
ing knit over knit and purl over purl, until 1 row
remains on chart. BO with Color 2.

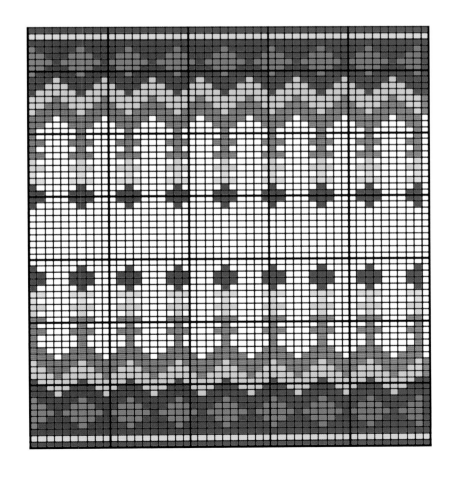

Five Wise Virgins is a good name for the pattern on this hat. Anyone familiar with Setesdal embroidery and *løyesaum* will be able to visualize this as a large embroidered piece.

HAT AND COWL
WITH *KLO*
(5 WISE VIRGINS)
PATTERN

The hat is worked with 96 stitches, a good stitch count since it is a multiple of 4. It's knitted with Vamse yarn on big needles and goes really quickly.

MATERIALS
Yarn: (CYCA #4), Rauma Vamse, 100% wool (91 yd/83 m / 50 g)
Yarn Amounts:
Color 1: Black V36, 50 g
Color 2: Red V18, 50 g
Color 3: Green V88, 50 g
Color 4: Pink V60, 50 g
Color 5: Blue V37, 50 g
Color 6: Yellow V25, 50 g

Needles: U.S. sizes 7 and 8 / 4.5 and 5: 16 in / 40 cm circulars; U.S. size 8 / 5 mm: set of 5 dpn

Gauge: 21 sts and 24 rows = 4 x 4 in / 10 x 10 cm. Adjust needle sizes to obtain correct gauge if necessary.

HAT
With smaller size circular and Color 1, CO 96 sts. Join, being careful not to twist cast-on row. Place marker for beginning of round. Work 8 rnds k2, p2 ribbing.
Change to larger size circular and work following the chart. The charted repeat is worked 4 times around with 1 repeat of the 34 rnds. Now shape the crown as follows:
Rnd 35: (K1, k2tog, k18, k2tog, k1) around.
Rnd 36: K88.
Rnd 37: (K1, k2tog, k16, k2tog, k1) around.
Rnd 38: K80.
Rnd 39: (K1, k2tog, k14, k2tog, k1) around.
Rnd 40: K72.
Rnd 41: (K1, k2tog, k12, k2tog, k1) around.
Rnd 42: K64.
Rnd 43: (K1, k2tog, k10, k2tog, k1) around.
Rnd 44: K56.
Rnd 45: (K1, k2tog, k8, k2tog, k1) around.
Rnd 46: K48.
Rnd 47: (K1, k2tog, k6, k2tog, k1) around.

Rnd 48: K40.
Rnd 49: (K1, k2tog, k4, k2tog, k1) around.
Rnd 50: K32.
Rnd 51: (K1, k2tog, k2, k2tog, k1) around.
Rnd 52: K24.
Rnd 53: (K1, k2tog, k2tog, k1) around.
Rnd 54: K16.
Rnd 55: (K1, k2tog, k1) around.

Cut yarn and draw end through rem 12 sts. Pull tightly and weave in all ends neatly on WS. Lightly steam press the hat under a damp pressing cloth but do not press ribbing.

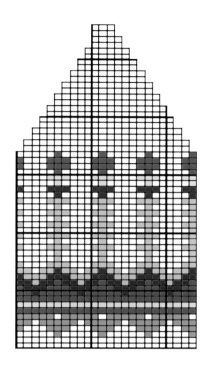

This neck warmer is the garment for anyone who prefers the freedom of a separate neckband when high-necked sweaters are too warm.

FINISHED MEASUREMENTS
12¼ in / 31 cm wide and 10¼ in / 26 cm high

MATERIALS
Yarn: (CYCA #3) Rauma Mitu, 50% superfine alpaca and 50% wool yarn (DK weight, 109 yd/100 m / 50 g)
Yarn Amounts:
Color 1: Black SFN50, 150 g
Color 2: Pink 1832, 50 g
Color 3: Yellow 0184, 50 g
Color 4: Green 6315, 50 g

NOTE: Hold 2 strands of yarn together throughout.

Needles: U.S. sizes 8 and 9 / 5 and 5.5: 24 in / 60 cm circulars

Gauge: 16 sts and 21 rows in stockinette on larger needles = 4 x 4 in / 10 x 10 cm.
Adjust needle sizes to obtain correct gauge if necessary.

COWL
With smaller size circular and 2 strands of Color 1 held together, CO 96 sts. Join, being careful not to twist cast-on row. Place marker for beginning of round. Work 8 rnds k2, p2 ribbing.
Change to larger size circular and work following the chart. The charted repeat is worked 8 times around and once in length. After completing charted rows, change back to smaller size circular and work 8 rnds k2, p2 ribbing. BO loosely.

Weave in all ends neatly on WS. Lightly steam press the cowl under a damp pressing cloth but do not press ribbing.

NOTE: All white squares on both charts are knitted with Black.

It was much more common for people in the old days to wear wrist warmers, so why not revive the tradition? Knit a pair in bright colors and spiff up that suit! Knitting the wise virgins motif is easier and faster than embroidering it.

WRIST WARMERS
WITH *KLO* (5 WISE VIRGINS) PANELS

FINISHED MEASUREMENTS
Circumference: 9 in / 23 cm
Length: 6¼ in / 16 cm

MATERIALS
Yarn: (CYCA #3), Rauma Mitu, 50% superfine alpaca and 50% wool yarn (DK weight, 109 yd/100 m / 50 g)
Yarn Amounts:
Color 1: Black SFN50, 50 g
Color 2: Red 4932, 50 g
Color 3: Yellow 0184, 50 g
Color 4: Blue 4922, 50 g
Color 5: Green 6315, 50 g
Color 6: Pink 1832, 50 g

Needles: U.S. sizes 2-3 and 4 / 3 and 3.5: set of 5 dpn

Gauge: 22 sts and 28 rows in stockinette on larger needles = 4 x 4 in / 10 x 10 cm after blocking. Adjust needle sizes to obtain correct gauge if necessary.

WRIST WARMERS
With smaller size dpn and Color 1, CO 48 sts. Join, being careful not to twist cast-on row. Divide sts evenly over 4 dpn = 12 sts per dpn. Work around in k2, p2 ribbing for 1¼ in / 3 cm.

Change to larger size dpn and work in pattern, following the chart. Work chart repeat twice around and

once in length. Finish by changing to smaller dpn and working in k2, p2 ribbing for 1¼ in / 3 cm. BO loosely.

Weave in all ends neatly on WS. Lightly steam press the cuffs under a damp pressing cloth but do not press ribbing.

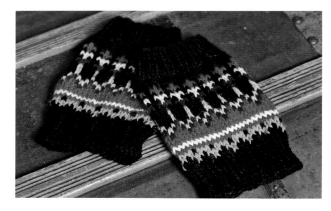

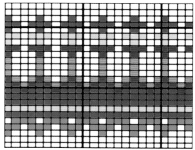

NOTE: All the white squares on the chart are knitted with Black.

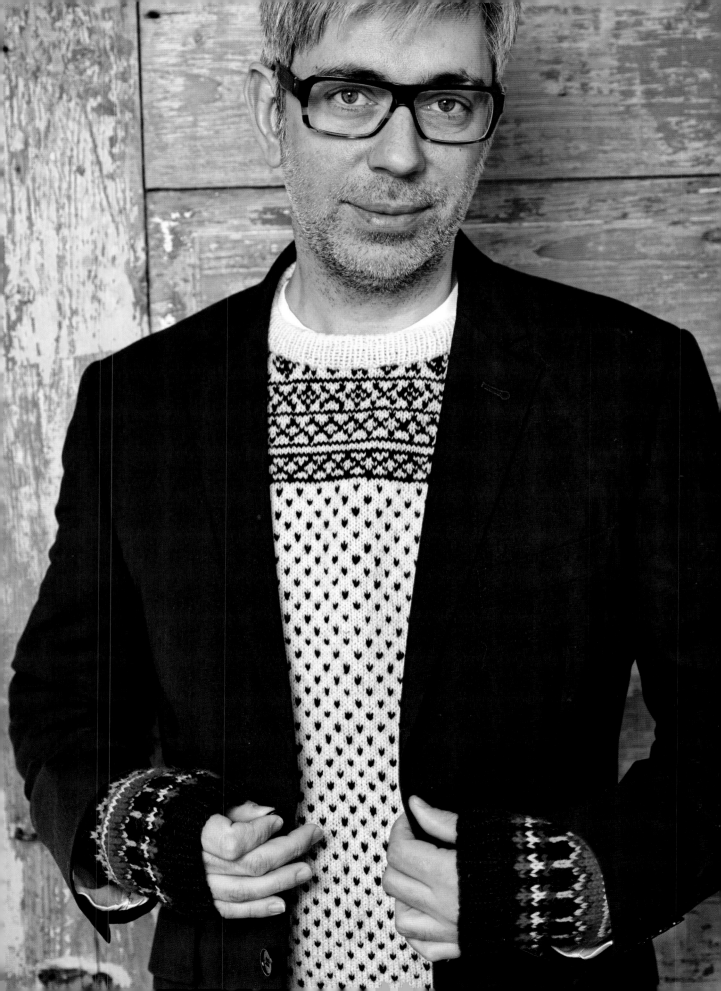

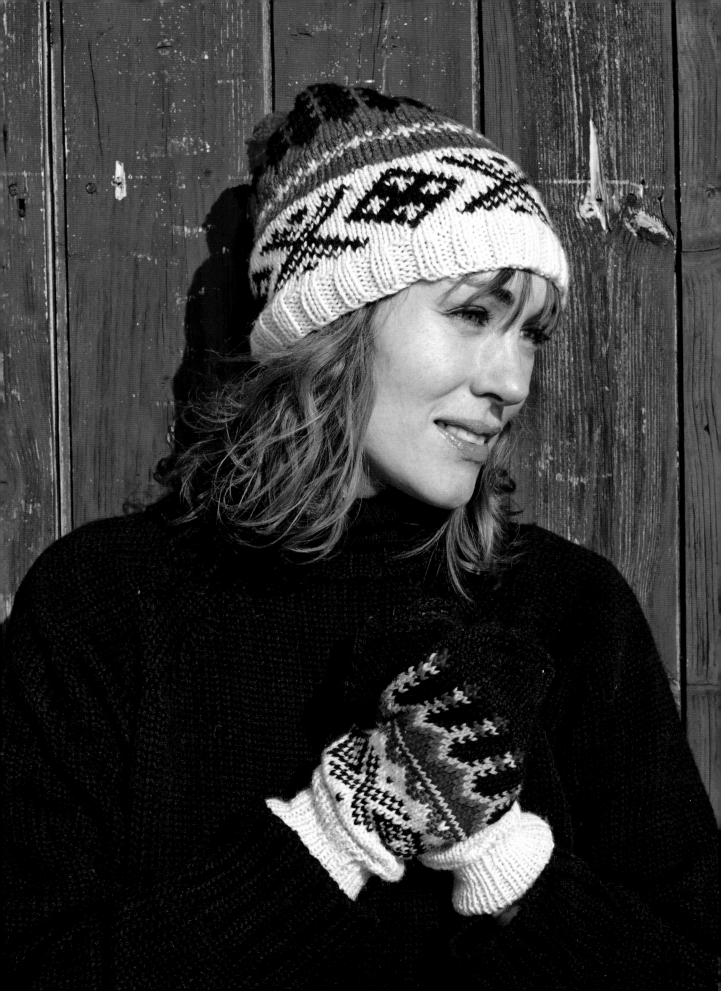

Knitwear factories started to add panels of cross and ring patterns on a white background at the beginning of the 1950s. Before that, this variation was not used in Setesdal.

HAT AND MITTENS
WITH *KLO* (5 WISE VIRGINS) AND CROSS AND RING MOTIFS

The hat features green and red in the wise virgins panel, which contrasts nicely with the black and white below.

FINISHED MEASUREMENTS
Circumference: 19 in / 48 cm
Length: 10¼ in / 26 cm (excluding tassel)

MATERIALS
Yarn: (CYCA #4), Rauma Vamse, 100% wool
(91 yd/83 m / 50 g)
Yarn Amounts:
Color 1: Black V36, 50 g
Color 2: Red V18, 50 g
Color 3: Green V88, 50 g
Color 4: White V01, 50 g

Needles: U.S. sizes 7 and 8 / 4.5 and 5: 16 in / 40 cm circulars; U.S. size 8 / 5 mm: set of 5 dpn

Gauge: 21 sts and 24 rows = 4 x 4 in / 10 x 10 cm. Adjust needle sizes to obtain correct gauge if necessary.

HAT
With smaller size circular and Color 4, CO 96 sts. Join, being careful not to twist cast-on row. Place marker for beginning of round. Work 8 rnds k2, p2 ribbing.
Change to larger size circular and work following the chart (see page 55). The charted repeat is worked 4 times around with 1 repeat of the 38 rnds. Now continue in pattern while you shape the crown as follows:

Rnd 39: K3, *k2tog, k4*; rep * to * until 3 sts rem and end k2tog, k1 = 80 sts rem.
Rnds 40-44: Knit.
Rnd 45: K1, *k2tog, k3*; rep * to * until 4 sts rem and end k2tog, k2 = 64 sts rem.
Rnds 46-47: Knit.
Rnd 48: K2tog with Color 2, *k2 with Color 1, k2tog with Color 2*; rep from * to * until 2 sts rem and end with k2 with Color 1 = 48 sts rem.
Rnd 49: Knit.
Rnd 50: (K2tog with Color 2) around = 24 sts rem.
Rnd 51: Knit.
Rnd 52: (K2tog with Color 2, k2tog with Color 1) around = 12 sts rem.
Rnd 53: (K2tog with Color 2, k2tog with Color 1) around = 6 sts rem.

Cut yarn and draw end through rem 6 sts; pull tight. Weave in all ends neatly on WS. Lightly steam press the hat under a damp pressing cloth but do not press ribbing.

Add a red tassel if you like—we think this would be a great finish after the red stripes.

Mittens and charts follow on the next two pages.

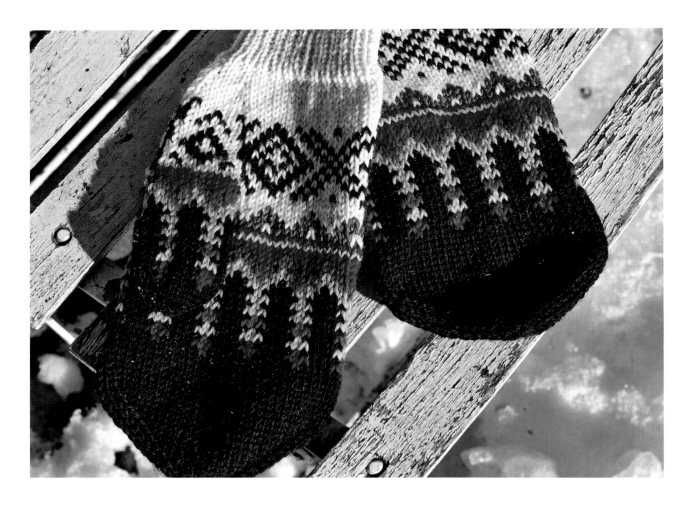

FINISHED MEASUREMENTS

Total length: 11½ in / 29 cm
Circumference: 9½ in / 24 cm

MATERIALS

Yarn: (CYCA #2), Rauma PT5, 80% wool, 20% nylon
(140 yd/128 m / 50 g)
Yarn Amounts:
Color 1: White 503, 50 g
Color 2: Black 512, 50 g
Color 3: Green 588, 50 g
Color 4: Red 543, 50 g
Color 5: Yellow 515, 50 g
Color 6: Pink 579, 50 g
Color 7: Blue 572, 50 g

Needles: U.S. sizes 2-3 and 4 / 3 and 3.5 mm:
set of 5 dpn

Gauge: 25 sts and 30 rows in stockinette on larger
needles = 4 x 4 in / 10 x 10 cm.
Adjust needle sizes to obtain correct gauge if
necessary.

MITTENS

With smaller size dpn and Color 1, CO 50 sts. Join,
being careful not to twist cast-on row. Divide sts as
evenly as possible onto dpn and work in k1, p1 ribbing
for 2¾ in / 7 cm. Change to larger dpn and work
pattern, following the chart. Increase for the thumb
gusset as indicated on the chart. At the arrow on the
chart, place 13 sts of thumb gusset on a holder and
CO 13 sts over gap = 60 sts.

After completing charted rows, continue in stocki-
nette with Color 2 only. Work until mitten measures
6¾ in / 17.5 cm from ribbing or desired length to top
shaping (knitting reaches tip of little finger). Divide
the sts with 15 sts each on 4 dpn. Now shape the
mitten top as follows:
Ndls 1 and 3: K1, ssk, knit to end of needle.
Ndls 2 and 4: Knit until 3 sts rem; k2tog, k1.
Decrease the same way on every round until 8 sts
rem. Cut yarn and draw through remaining sts. Pull
tight and weave in all ends on WS.

Chart—Hat

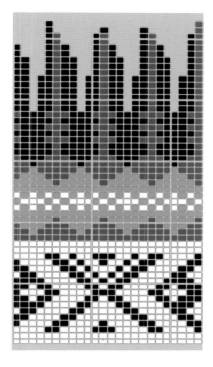

THUMB

Divide held sts onto 2 dpn and then, with larger dpn and Color 5, pick up and knit 13 sts on top of thumb-hole = 26 sts. Work the thumb pattern, following the chart, shaping tip as shown on chart. Cut yarn and draw through rem sts. Pull tight and weave in all ends on WS.

Make the other mitten the same way, reversing placement of thumb on palm.

Chart—Thumb

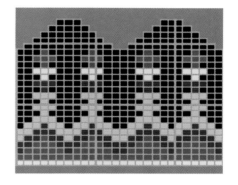

Chart—Mittens

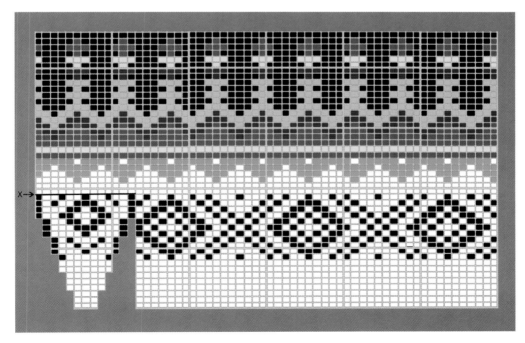

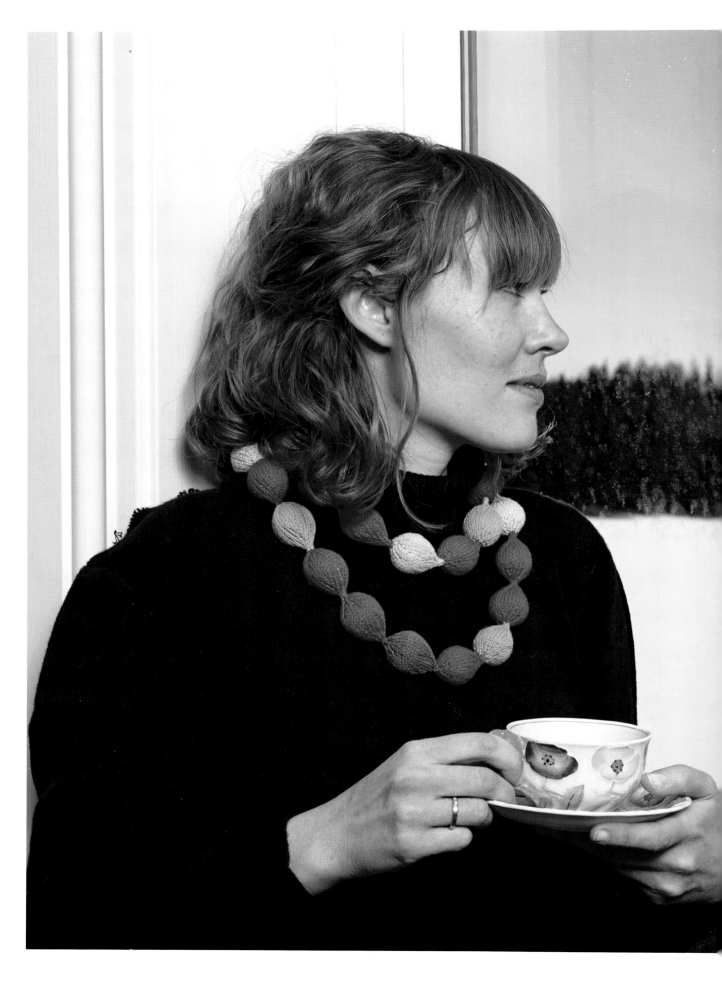

This necklace has 30 balls, inspired by the embroidered ball motifs on the yoke of a Setesdal women's folk costume (see fragment at far right in the photo on page 59) that we got from Arne's aunt in Kristiansand. The colors are the same as for our necklace: pink, purple, green, and red.

NECKLACE

MATERIALS
Yarn: (CYCA #1), PT Pandora, 100% cotton (180 yd/165 m / 50 g)
Yarn Amounts: 1 ball each:
Pink 251
Purple 279
Green 215
Red 256
Yellow 201

NOTE: Alternately, you can use leftover yarns. Some knitters will want to know exactly how many grams are needed for each ball, but we must disappoint you. We didn't weigh each ball and can't tell you how many grams went into one, but you can knit a necklace many yards/meters long with 1 ball of each color.

Needles: U.S. size 1-2 / 2.5 mm: set of 5 dpn
Notions: Wool batting
Gauge: ⅜ in / 1 cm = 4 sts in width; our necklace was 57 in / 145 cm long.
Adjust needle size to obtain correct gauge if necessary.

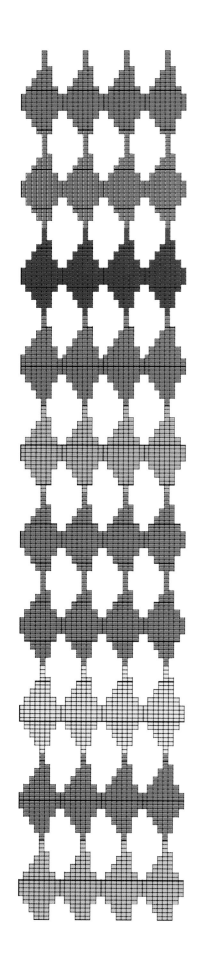

NECKLACE

With any color, CO 12 sts; join and divide sts evenly onto 4 dpn = 3 sts per needle.

NOTE: Work RLI increases into right side of next st to be worked.

Rnd 1: K12.
Rnd 2: (K2, RLI, k1) around.
Rnd 3: K16.
Rnd 4: (K1, RLI, k2, RLI, k1) around.
Rnd 5: K24.
Rnd 6: (K1, RLI, k4, RLI, k1) around.
Rnds 7-9: K32.
Rnd 10: (K1, k2tog, k2, k2tog, k1) around.
Rnd 11: K24.
Rnd 12: (K1, k2tog, k2tog, k1) around.
Rnd 13: K16.
Rnd 14: (K1, k2tog, k1) around.
Rnd 15: K12.
Rnd 16: (K1, k2tog) around.
Fill ball with wool batting.
Rnd 17: (K2tog) around and divide rem sts over 2 dpn.
Rnds 18-19: K4.
Change colors. Weave in ends as you work.
Rnds 20-21: K4.
Rnd 22: Now begin increasing: (M1knitwise, k1, M1purl-wise) around = 12 sts. Divide sts evenly onto 4 dpn.
Repeat Rnds 1-22 until necklace is desired length.
End last ball with Rnd 21 and sew the last ball securely to the first.

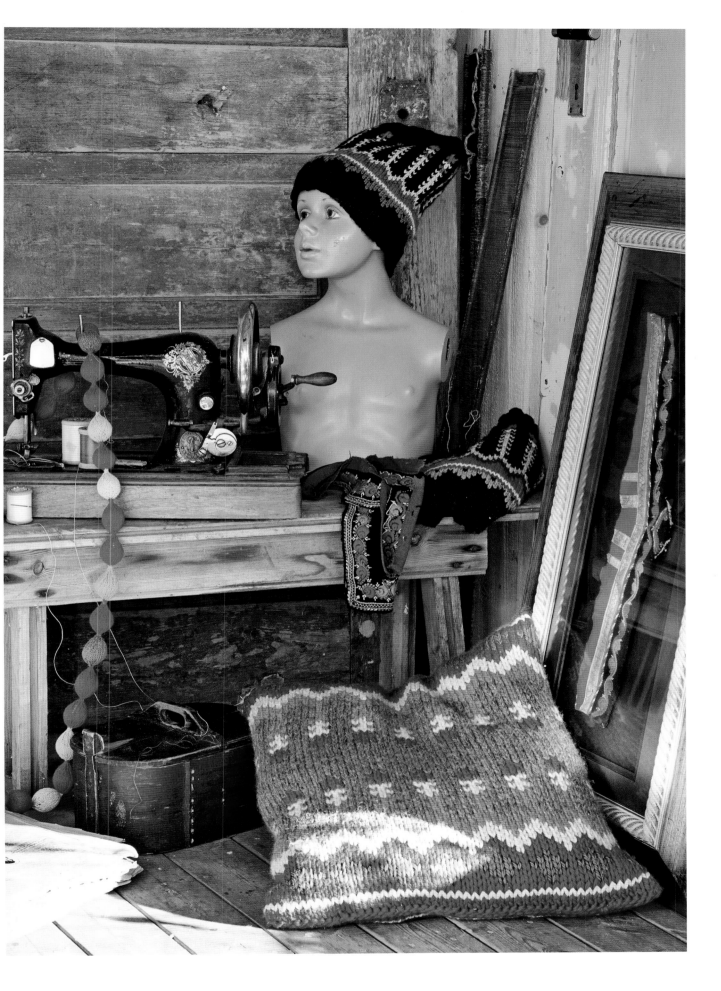

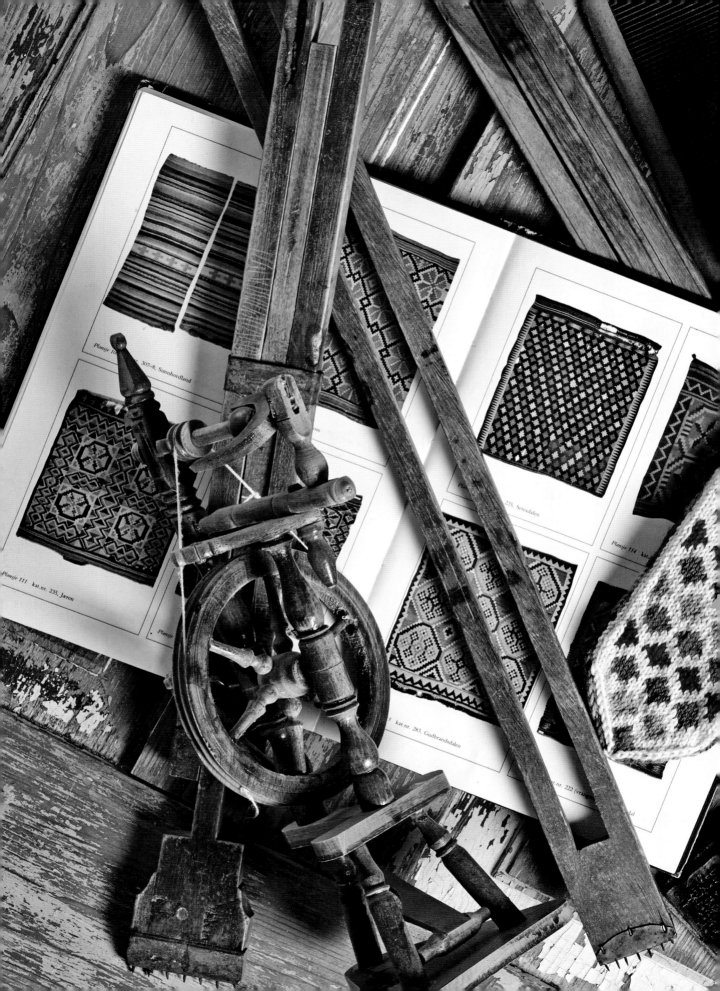

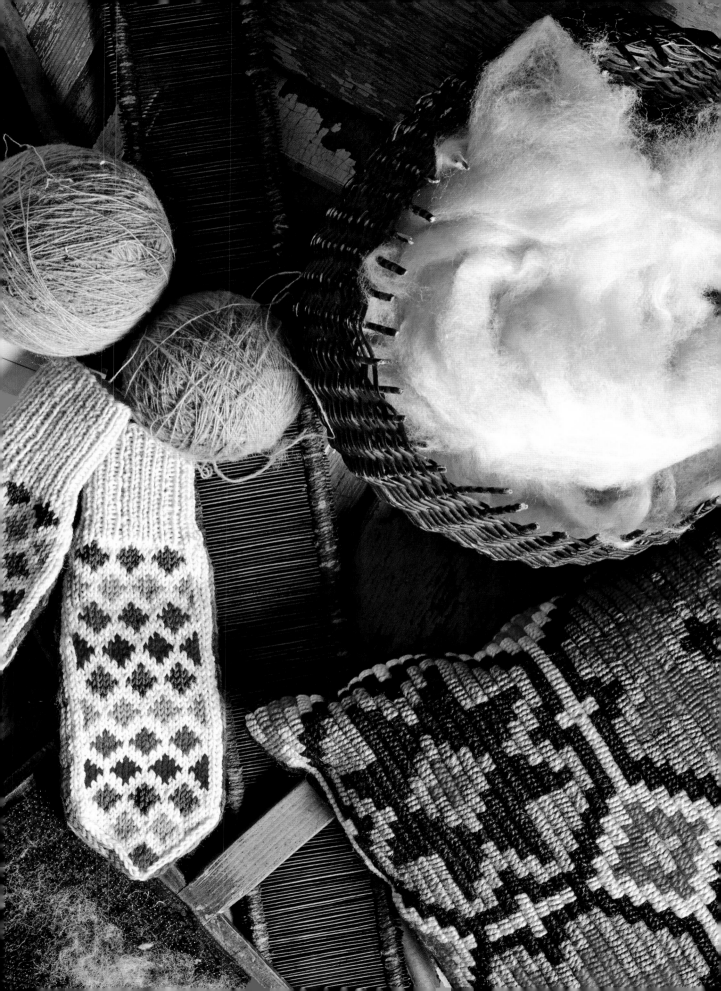

WEAVING

Our inspiration for this chapter is a woven tapestry (plate 113) which we noticed in the book *Block Tapestries* by Marit Wang. The same type of weaving can be seen in the painting *A Setesdal Cottage* by Carl Sundt-Hansen, which depicts a Setesdal couple and a Norwegian zither or *langeleik*. These weavings both feature rhomboids in several colors.

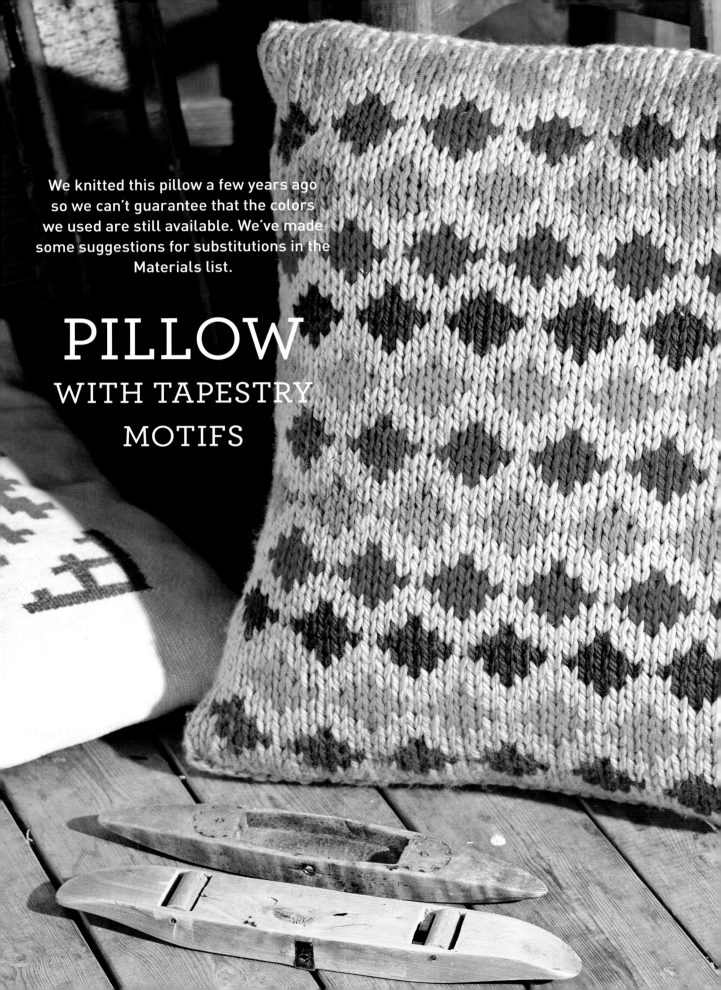

We knitted this pillow a few years ago so we can't guarantee that the colors we used are still available. We've made some suggestions for substitutions in the Materials list.

PILLOW
WITH TAPESTRY
MOTIFS

FINISHED MEASUREMENTS

17¾ x 17¾ in / 45 x 45 cm

MATERIALS

Yarn: (CYCA #4), Rauma Vamse, 100% wool
(91 yd/83 m / 50 g)
Yarn Amounts:
Color 1: Brown V64, 200 g
Color 2: Red V24, 50 g
Color 3: Blue V49, 50 g
Color 4: Orange V61, 50 g
Color 5: Purple V57, 50 g
Color 6: Green V80, 50 g

NOTE: Hold 2 strands of yarn together throughout.

Needles: U.S. size 10½ / 6.5 mm: 32 in / 80 cm
circular

Notions: Pillow form, 24 x 24 in / 60 x 60 cm. The
finished pillow measures approx. 17¾ x 17¾ in / 45 x
45 cm, but we used a larger pillow form since a form
the same size as the pillow cover flattens out with

use. The larger form helps the pillow keep its shape
and plumpness longer.

Gauge: 10 sts and 14 rows = 4 x 4 in / 10 x 10 cm.
Adjust needle size to obtain correct gauge if
necessary.

PILLOW

With 2 strands of Color 1 held together, CO 100 sts.
Join, being careful not to twist cast-on row. Place
marker for beginning of round. Work (P1, k49) 2
times. The cast-on row + the first row worked
correspond to the first 2 rows of the chart. Continue,
following the chart and working knit over knit and
purl over purl, until 1 row remains on chart. BO with
Color 1.

FINISHING

Weave in ends neatly on WS and then steam press
pillow cover under a damp pressing cloth. With Color
1, seam one end of the pillow, making sure that the
purl stitches are at the sides. Insert pillow form. Use
Color 1 to seam the other end of the pillow and weave
in remaining ends.

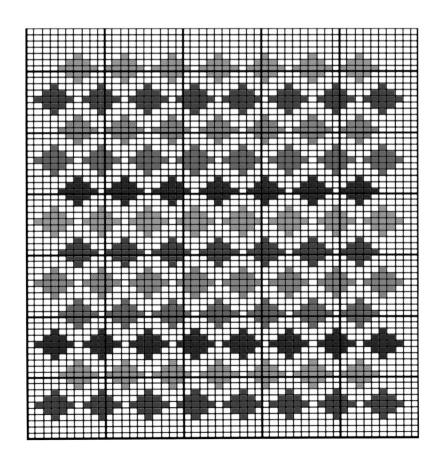

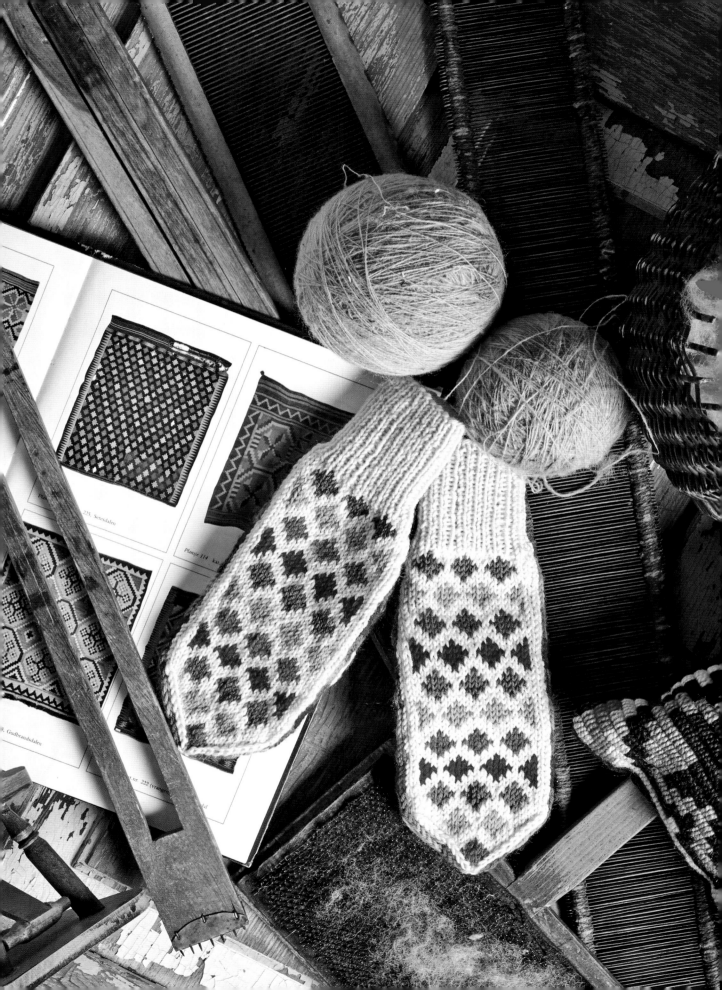

These mittens feature solid color diamonds on the back of the hand and a netting pattern on the palm. We sized the mittens for both girls and women. An *åkle* is a woven tapestry hung on the walls in old Norwegian homes.

MITTENS
WITH *ÅKLE* TAPESTRY MOTIFS

SIZES
Girl's (Women's) mittens with *åkle* tapestry motifs

FINISHED MEASUREMENTS
Total length: 9¾ (11½) in / 25 (29) cm
Circumference: 8 (9½) in / 20 (24) cm

MATERIALS
Yarn: (CYCA # 2), Rauma PT5, 80% wool, 20% nylon (140 yd/128 m / 50 g)
Yarn Amounts:
Color 1: White 503, 50 g
Color 2: Green 588, 50 g
Color 3: Blue 571, 50 g
Color 4: Purple 562, 50 g
Color 5: Red 543, 50 g

Needles: U.S. sizes 2-3 and 4 / 3 and 3.5 mm: set of 5 dpn

Gauge: 25 sts and 30 rows in stockinette on larger needles = 4 in / 10 cm.
Adjust needle sizes to obtain correct gauge if necessary.

MITTENS
With smaller needles and Color 1, CO 42 (52) sts; divide sts as evenly as possible over 4 dpn. Join, being careful not to twist cast-on row. Work around in k1, p1 rib for 2½ in / 6 cm.

Change to larger dpn and work in pattern, following the chart. Increase for the thumb gusset as indicated

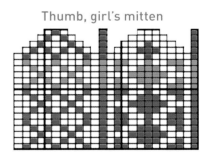

Thumb, girl's mitten

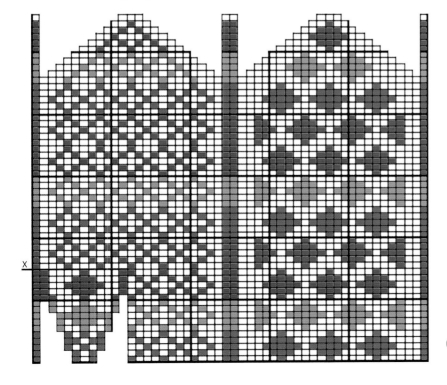

X

Girl's mitten

on the chart. Increase with M1R before and M1L after the center set of sts of thumb gusset. When you reach the row marked with X at the left side of the chart, place the 11 (13) thumb sts on a holder. CO 11 (13) sts over the gap = 50 (62) sts.

Now divide the sts with 12 (16) sts each on dpn 1 and 3 and 13 (15) sts each on dpn 2 and 4. Continue, following the chart. Shape the top with decreases on each side of the 2-st bands at sides of hand.

Top Shaping: At the beginning of dpn 1 and 3: Ssk (or sl 1, k1, psso); knit to end of needle. At the end of dpn 2 and 4: K2tog.

End by cutting yarn and drawing through remaining 10 sts; tighten. Weave in all ends neatly on WS.

THUMB
Slip sts on holder to larger size dpn; knit across in pattern and then pick up and knit 11 (13) sts above thumbhole + 1 st at each side = 24 (28) sts total. Work in pattern, following the thumb chart. Shape top of thumb as shown on chart. End by cutting yarn and drawing through remaining 8 sts; tighten. Weave in all ends neatly on WS.

Make the other mitten the same way, placing thumb on opposite side of palm.

Women's mitten

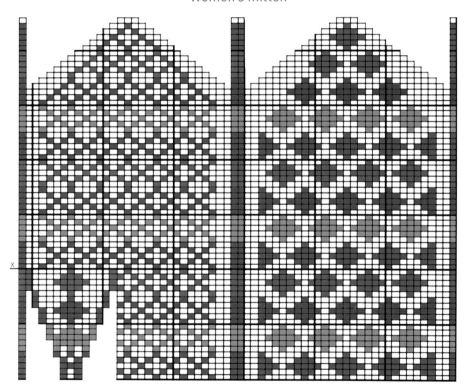

Thumb, women's mitten

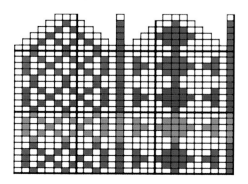

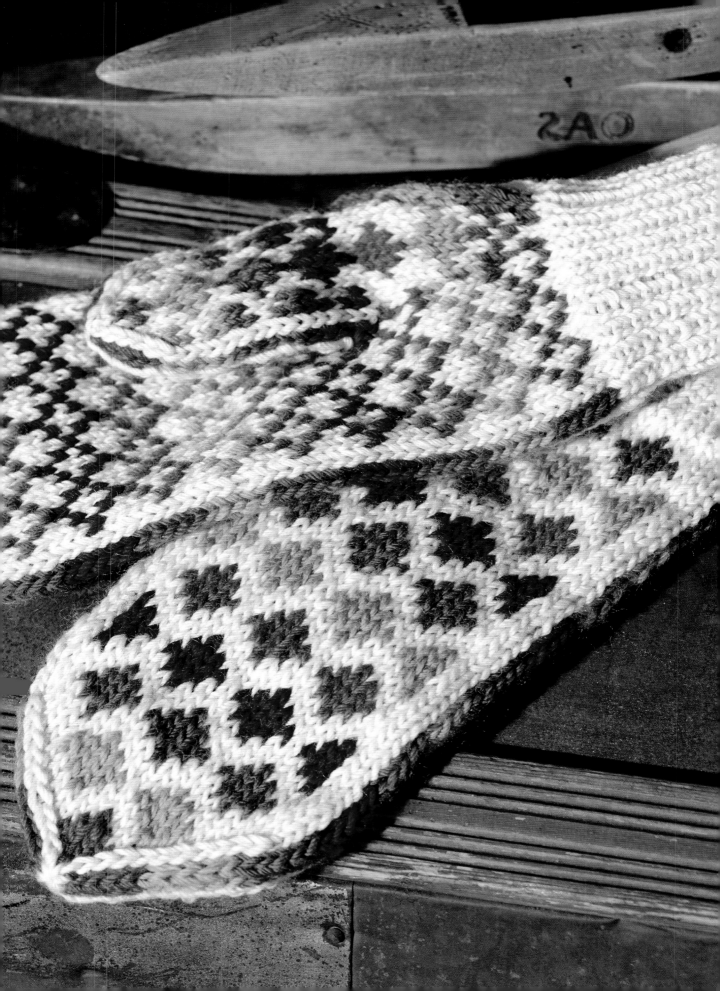

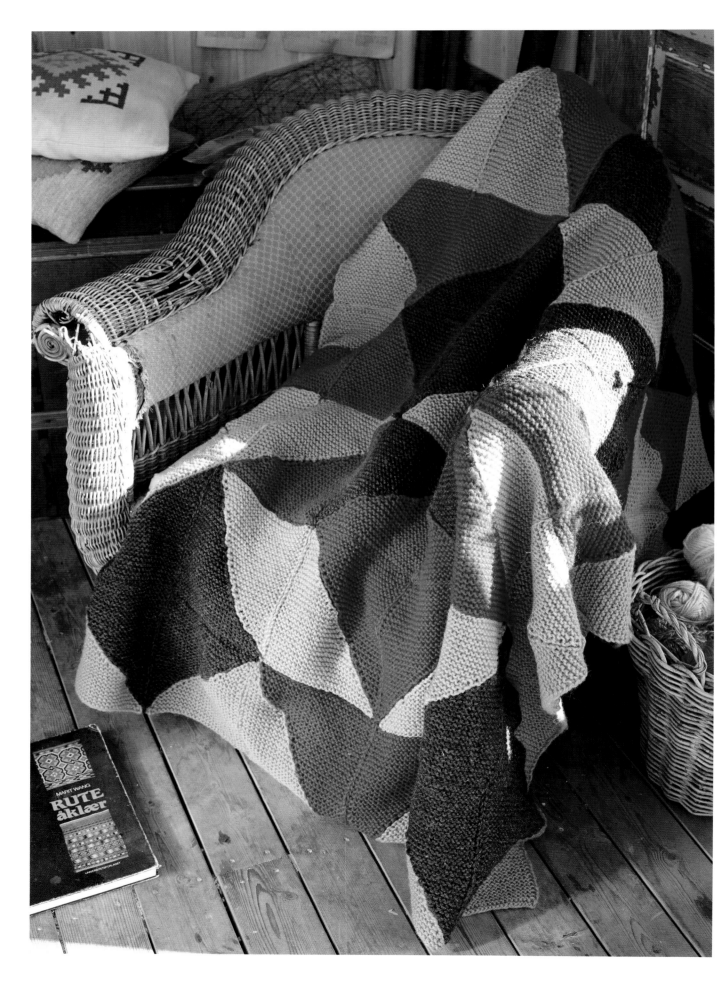

This quilt is constructed with triangles. Each triangle is 30 stitches wide and shaped by decreasing on one side. Make sure that the garter ridges all go in the same direction when you sew the quilt together.

QUILT

FINISHED MEASUREMENTS
2 yd, 6 in / 2 m long and 1⅓ yd / 1.23 m wide

MATERIALS
Yarn: (CYCA #4), Rauma Vamse, 100% wool
(91 yd/83 m / 50 g)
Yarn Amounts:
Color 1: Brown V64, 350 g
Color 2: Dark Red V35, 300 g
Color 3: Mustard V46, 350 g
Color 4: Purple V71, 200 g
You will also need 3 balls (total of 150 g) for seaming.
We used brown for sewing the triangles together. 1
ball will make 4 triangles.

Needles: U.S. size 8 / 5 mm

Gauge: 30 sts = 7 in / 18 cm and 30 ridges (60 rows) =
9 in / 23 cm.
Adjust needle size to obtain correct gauge if necessary.

TRIANGLE
CO 30 sts.

Row 1: Sl 1 purlwise, knit to end of row.
Row 2: Ssk, knit to end of row.
Repeat these 2 rows until 3 sts rem. Sl 1, k2. BO.

Make 28 triangles with Color 1, 24 with Color 2, 28 with Color 3, and 16 with Color 4. Sew the blocks together—see schematic on page 143 for assembly. Weave in all ends neatly on WS.

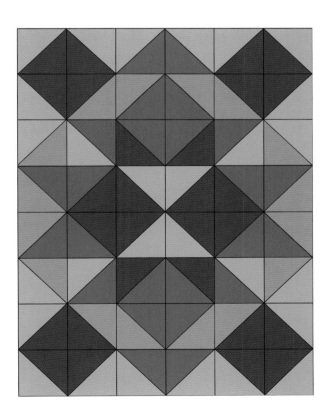

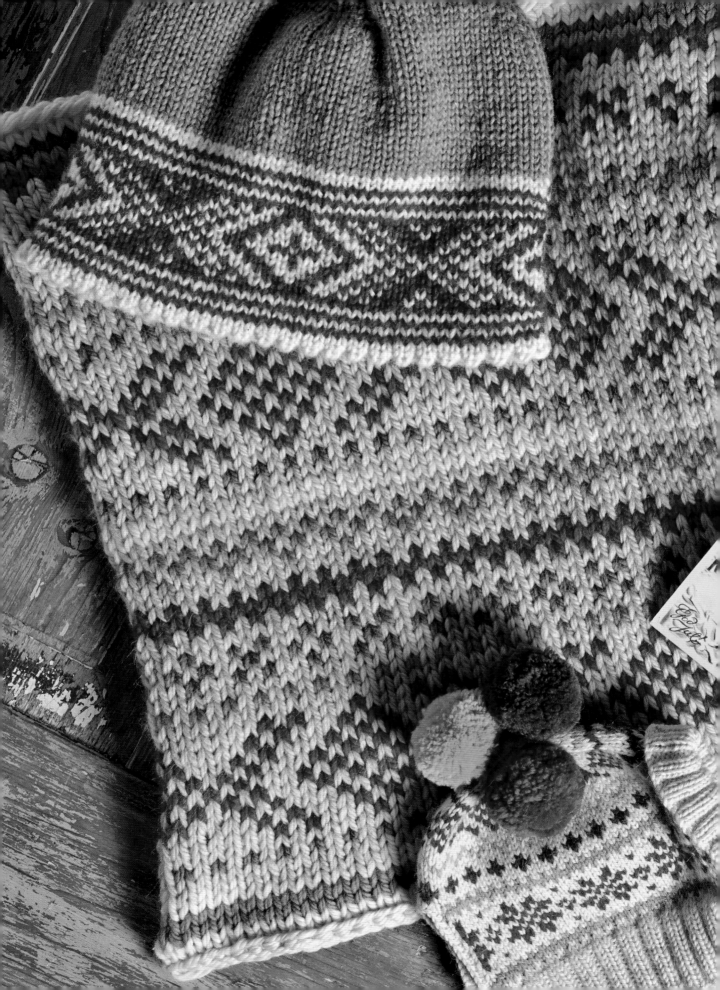

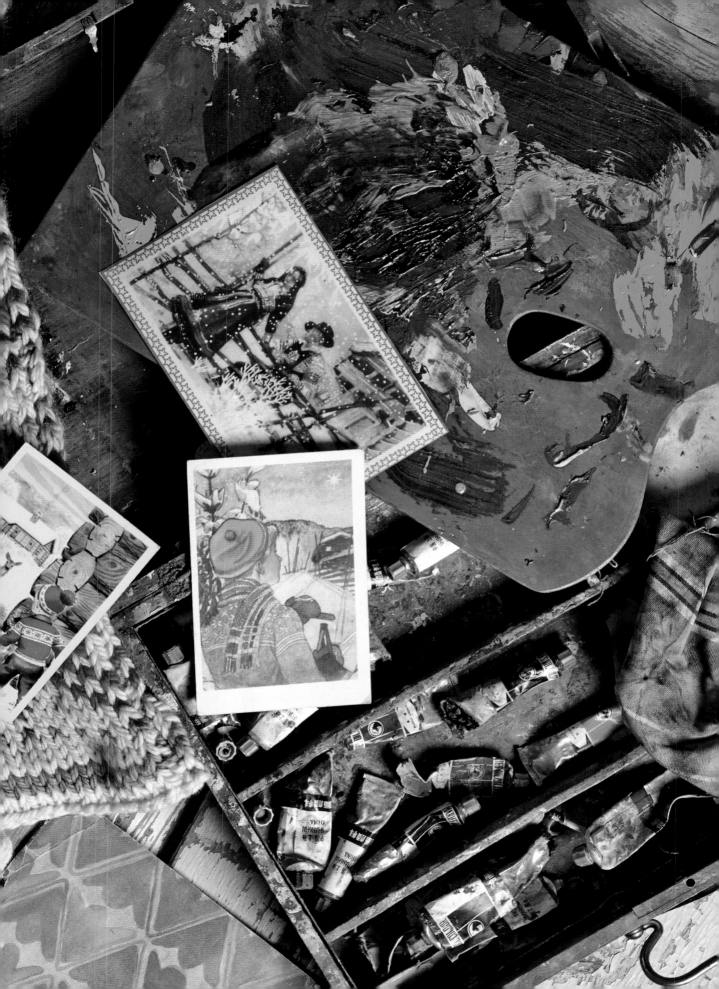

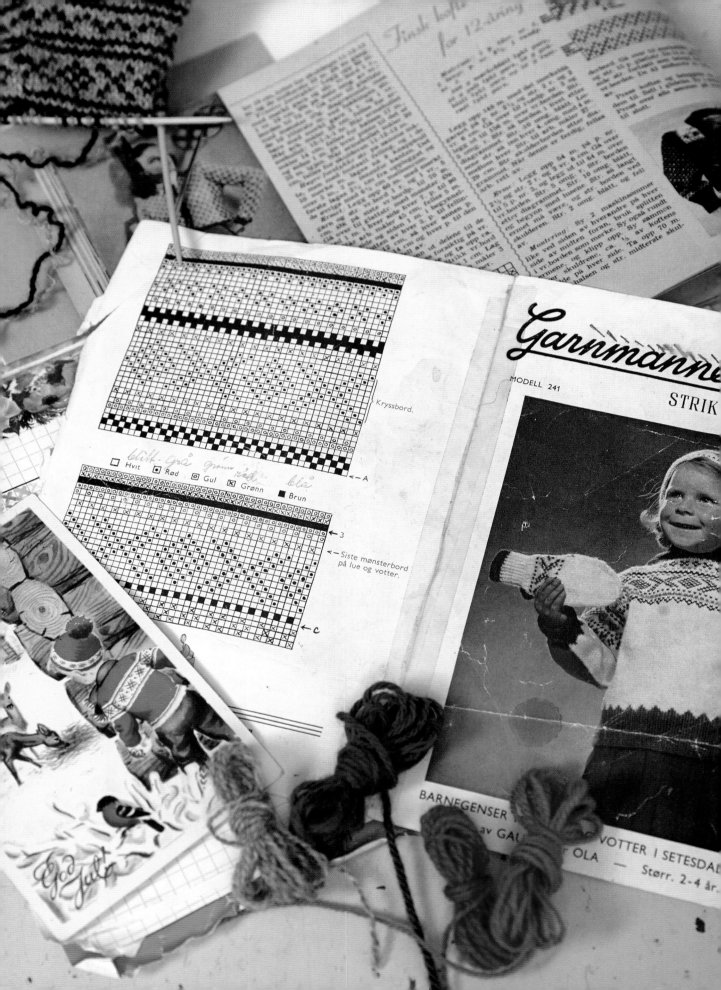

Kryssbord.

blått, grå, grønn, rød, blå

□ Hvit ■ Rød ⊡ Gul ⊠ Grønn ■ Brun

← A

← 3

← Siste mønsterbord
på lue og votter.

← c

Garnmannen

MODELL 241

STRIK

BARNEGENSER
av GAU

VOTTER I SETESDAL
OLA — Størr. 2-4 år.

CHRISTMAS CARDS

After the dissolution of the union with Sweden, many Norwegian Christmas cards appeared with people and *nisser* (gnomes) painted in Norwegian sweaters with simplified patterns and bright colors. A sweater like that was also on a Christmas card that Annemor Sundbø found in her grandmother's childhood home in Setesdal. The picture on the card was painted by Trygve M. Davidsen in 1935.

Simplified Setesdal motifs in several colors were also common on children's sweaters at that time and are still popular today. You might think that this was a way to use up leftover yarns because each pattern panel used different colors. One example is the "Setesdal Sweater for Children" from Garnmannen, which came out at the end of the 1940s. Arne found this pattern in the attic of his mother and father's home. The garment was designed to be knit in white, red, yellow, green, and brown.

The *New Knitting Book* (1948) features a Norwegian lice sweater for children, a white pullover with red patterns. Many who grew up in the 1950s and 1960s have certainly worn these simplified Setesdal sweaters. Girls' sweaters were often red with white motifs, almost identical to the sweater in the Christmas card shown opposite. Boys' sweaters were usually blue with white motifs.

On the simple model from Garnmannen, the lice have been eliminated and the zigzag panel formerly placed on the sleeve has been replaced by the cross and ring.

We call our sweater the "Christmas card sweater" because the oldest pictures we found of this type of sweater were found on Christmas cards. So, thank you to the artist.

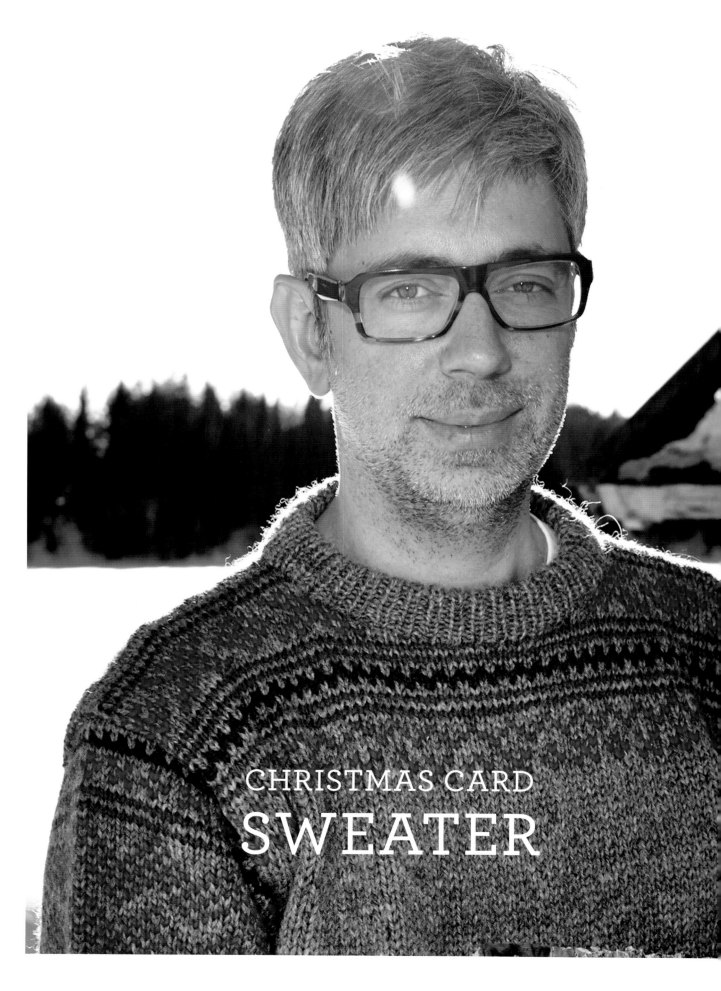

CHRISTMAS CARD
SWEATER

SIZES
Men's S (M, L, XL)

FINISHED MEASUREMENTS
Chest: 39¾ (41¼, 45, 47¾) in / 101 (105, 114, 121) cm
Total length: 26½ (26¾, 27½, 28¼) in / 67 (68, 70, 72) cm
Sleeve length: 21¼ (21¼, 22, 22) in / 54 (54, 56, 56) cm

MATERIALS
Yarn: (CYCA #4), Rauma Vamse, 100% wool
(91 yd/83 m / 50 g)
Yarn Amounts:
Color 1: Gray V13, 550 (550, 600, 650) g
Color 2: Red V18, 50 (50, 50, 50) g
Color 3: Blue V67, 50 (50, 50, 50) g
Color 4: Green V88, 50 (50, 50, 50) g
Color 5: Burnt Orange V42, 50 (50, 50, 50) g

Needles: U.S. sizes 7 and 8 / 4.5 and 5 mm: circulars
and sets of 5 dpn

Gauge: 16 sts and 22 rnds in stockinette on larger
needles = 4 x 4 in / 10 x 10 cm.
Adjust needle sizes to obtain correct gauge if
necessary.

BODY
With smaller size circular and Color 1, CO 160 (168, 180,
192) sts. Join, being careful not to twist cast-on row.
Place marker for beginning of rnd. Work around in k2,
p2 ribbing for 2½ in / 6 cm. Change to larger circular
and continue in stockinette, increasing 2 sts evenly
spaced on the 1st rnd = 162 (170, 182, 194) sts. Continue
around in stockinette until piece measures 21 (21¼, 22,
22¾) in / 53 (54, 56, 58) cm. Place a marker at each side
so there are 81 (85, 91, 97) sts each for front and back.

Now work in pattern, following Chart 1. Begin at the
arrow for your size = front. Repeat the pattern on the
back. After completing the 32 rows of the chart, place
the front and back sts each on a separate holder.

SLEEVES (MAKE BOTH ALIKE)
With smaller size dpn and Color 1, CO 44 (44, 48, 48)
sts. Join, being careful not to twist cast-on row, and
divide sts evenly onto dpn. Work around in k2, p2

ribbing for 2½ in / 6 cm. On the last rnd of ribbing, increase 3 (5, 3, 5) sts evenly spaced around = 47 (49, 51, 53) sts.

Change to larger size dpn and continue in stockinette. *At the same time*, increase 2 sts at center of underarm every ¾ in / 2 cm until there are 77 (79, 83, 87) sts. Increase as follows: K1, M1R, knit until 1 st rem, M1L, k1. Work new sts into pattern. When sleeve is 12¼ (12¼, 13, 13) in / 31 (31, 33, 33) cm long, work in pattern, following Chart 2. Work charted rows once, increasing as set. Make sure that the pattern is centered on the sleeve.

After completing charted rows, sleeve should be approx. 21¼ (21¼, 22, 22) in / 54 (54, 56, 56) cm long. Turn sleeve inside out and work facing in stockinette for ¾ in / 2 cm, *at the same time* increasing 2 sts at center of underarm on every other rnd. BO loosely.

FINISHING
Lay sleeve flat and measure the width at top of sleeve. Mark that amount down from the shoulder at each side of the sweater body. Machine-stitch 2 lines around the markers and then cut open at center of stitching. Attach sleeves, stitching by hand. Fold facing over cut edges on WS and sew down.

Mark the neck opening by hand basting the neckline. The neck opening should be 8 (8, 8¼, 8¾) in / 20 (20, 21, 22) cm wide, 2¾ in / 7 cm deep at center front, and ¾ in / 2 cm deep at center back. Round the neckline smoothly, making sure that the patterns match on both sides. Machine-stitch 2 lines inside the basting threads and then cut away excess fabric above stitching, leaving a small seam allowance. Join shoulders either with Kitchener stitch or 3-needle bind-off.

NECKBAND
With smaller size circular and Color 1, pick up and knit approx. 80 (80, 82, 84) sts around neck. Work around in k1, p1 ribbing for 2½ in / 6 cm. BO loosely. Fold neckband to WS and sew down, covering cut edges.

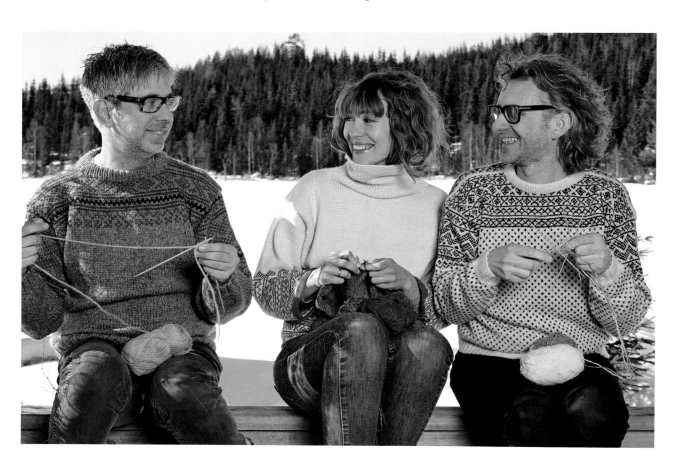

Chart 1—Body

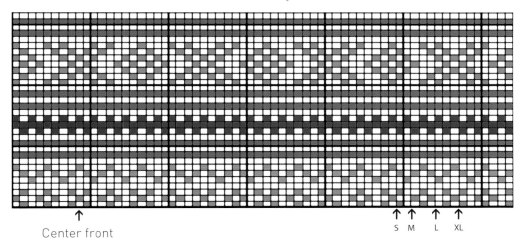

Center front

S M L XL

Chart 2—Sleeves

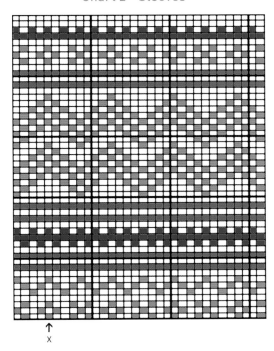

X

79

Our hat was inspired by a stocking cap from Setesdal. The stocking cap was a long cap knitted in red and black yarn with a crown shaped like a sock heel. It is mentioned in Johannes Skar's book *Gamalt or Setesdal II*. The hat shown in the book is red, green, and white, with the white part folded in as a lining.

DOUBLED HAT

SIZE
Women's M

MATERIALS
Yarn: (CYCA #4), Rauma Vamse, 100% wool
(91 yd/83 m / 50 g)
Yarn Amounts:
Color 1: White V01, 100 g
Color 2: Red V35, 50 g
Color 3: Green V80, 50 g

Needles: U.S. size 8 / 5 mm: 16 in / 40 cm circular
and set of 5 dpn

Gauge: 16 sts and 22 rnds in stockinette on larger
needles = 4 x 4 in / 10 x 10 cm.
Adjust needle sizes to obtain correct gauge if
necessary.

HAT
Begin with hat lining. With Color 1 and dpn, CO 12 sts.
Join, being careful not to twist cast-on row, and then
divide sts onto 4 dpn = 3 sts per needle.
Shape the hat as explained below. Begin on dpn and
change to short circular when dpn become too full.

Rnd 1: K12.
Rnd 2: (K1, M1, k2) around.
Rnd 3: K16.
Rnd 4: (K1, M1, k2, M1, k1) around.
Rnd 5: K24.
Rnd 6: (K1, M1, k4, M1, k1) around.
Rnd 7: K32.
Rnd 8: (K1, M1, k6, M1, k1) around.
Rnd 9: K40.
Rnd 10: (K1, M1, k8, M1, k1) around.
Rnd 11: K48.
Rnd 12: (K1, M1, k10, M1, k1) around.
Rnd 13: K56.
Rnd 14: (K1, M1, k12, M1, k1) around.
Rnd 15: K64.
Rnd 16: (K1, M1, k14, M1, k1) around.
Rnd 17: K72.
Rnd 18: (K1, M1, k16, M1, k1) around.
Rnd 19: K80.
Rnd 20: (K1, M1, k18, M1, k1) around.
Rnd 21: K88.
Rnd 22: (K1, M1, k20, M1, k1) around.
Rnds 23-62: K96 (= 40 rnds).
Rnd 63: (K2tog, yo) around = eyelet fold row.
Rnd 64: K96.

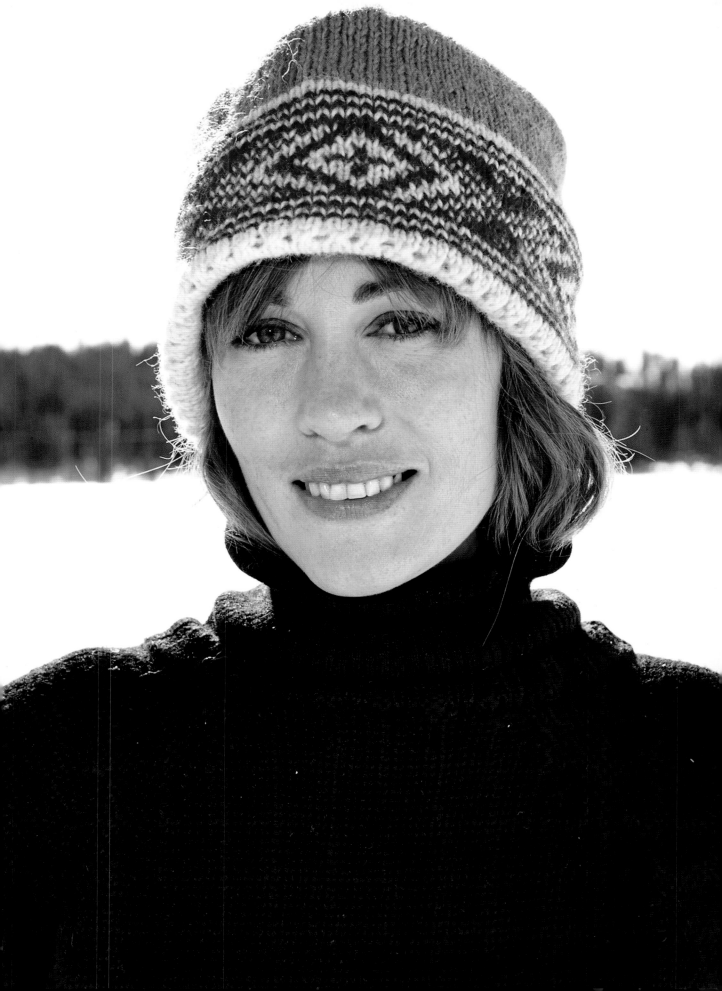

OUTSIDE OF HAT

Add Color 2 and work pattern, following the chart (changing to Color 3 on Rnd 24) through chart Row 42. The shaping shown at the top of the chart is worked as follows:

Rnd 43: (K1, k2tog, k18, k2tog, k1) around.
Rnd 44: K88.
Rnd 45: (K1, k2tog, k16, k2tog, k1) around.
Rnd 46: K80.
Rnd 47: (K1, k2tog, k14, k2tog, k1) around.
Rnd 48: K72.
Rnd 49: (K1, k2tog, k12, k2tog, k1) around.
Rnd 50: K64.
Rnd 51: (K1, k2tog, k10, k2tog, k1) around.
Rnd 52: K56.

Rnd 53: (K1, k2tog, k8, k2tog, k1) around.
Rnd 54: K48.
Rnd 55: (K1, k2tog, k6, k2tog, k1) around.
Rnd 56: K40.
Rnd 57: (K1, k2tog, k4, k2tog, k1) around.
Rnd 58: K32.
Rnd 59: (K1, k2tog, k2, k2tog, k1) around.
Rnd 60: K24.
Rnd 61: (K1, k2tog, k2tog, k1) around.
Rnd 62: K16.
Rnd 63: (K1, k2tog, k1) around.

Cut yarn and draw through rem 12 sts. Weave in all ends neatly on WS. Lightly steam press hat under damp pressing cloth. Fold in lining at eyelet round.

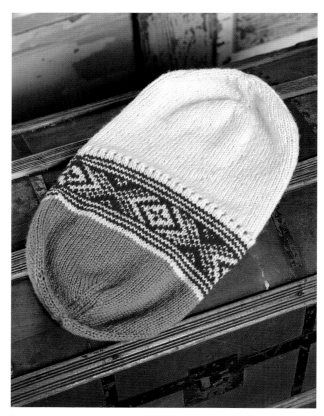

The photo shows the finished hat before the lining is folded in.

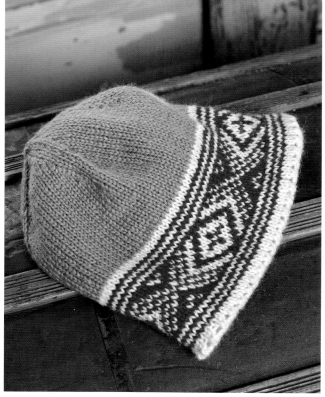

The doubled hat.

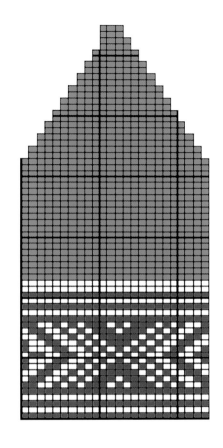

"He never changed his outfit; he went about in his homespun jacket and short pants and stocking cap as long as he lived."

This pillow features panels from the child's
sweater published by Garnmannen.

GARNMANNEN
PILLOW

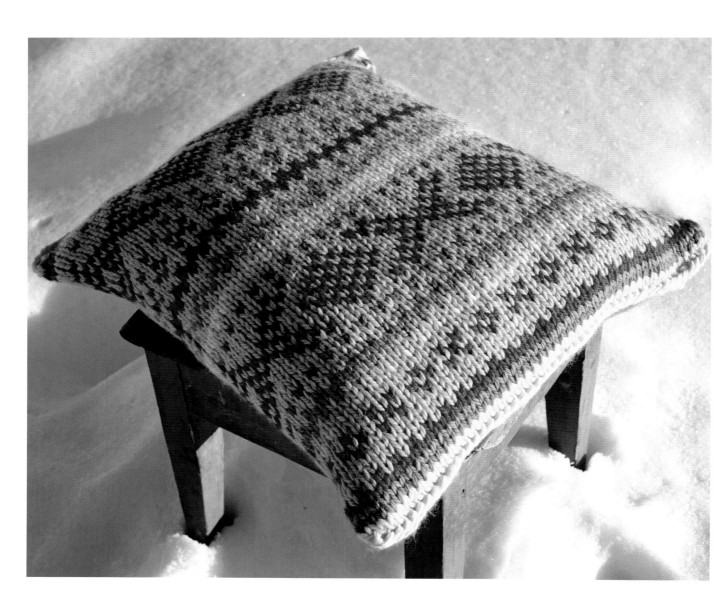

FINISHED MEASUREMENTS
17¾ x 17¾ in / 45 x 45 cm

MATERIALS
Yarn: (CYCA #4), Rauma Vamse, 100% wool
(91 yd/83 m / 50 g)
Yarn Amounts:
Color 1: Beige V06, 200 g
Color 2: Red V35, 100 g
Color 3: Yellow V20, 50 g
Color 4: Mustard V63, 50 g
Color 5: Green V88, 50 g

NOTE: Hold 2 strands of yarn together throughout.

Needles: U.S. size 10½ / 6.5 mm: 32 in / 80 cm
circular

Notions: Pillow form, 24 x 24 in / 60 x 60 cm. The
finished pillow measures approx. 17¾ x 17¾ in / 45 x
45 cm, but we used a larger pillow form since a form
the same size as the pillow cover flattens out with
use. The larger form helps the pillow keep its shape
and plumpness longer.

Gauge: 10 sts and 14 rows = 4 x 4 in / 10 x 10 cm.
Adjust needle size to obtain correct gauge if
necessary.

PILLOW
With 2 strands of Color 3 held together, CO 100 sts.
Join, being careful not to twist cast-on row. Place
marker for beginning of round. Work (P1, k49) 2
times. The cast-on row + the first row worked cor-
respond to the first 2 rows of the chart. Continue,
following the chart and working knit over knit and
purl over purl, until 1 row remains on chart. BO with
Color 3.

FINISHING
Weave in ends neatly on WS and then steam press
pillow cover under a damp pressing cloth. With Color
3, seam one end of the pillow, making sure that the
purl stitches are at the sides. Insert pillow form. Use
Color 3 to seam the other end of the pillow and weave
in remaining ends.

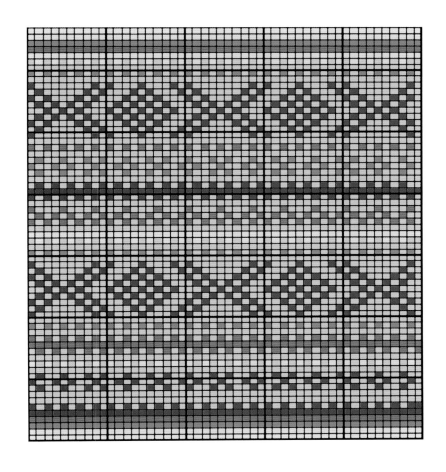

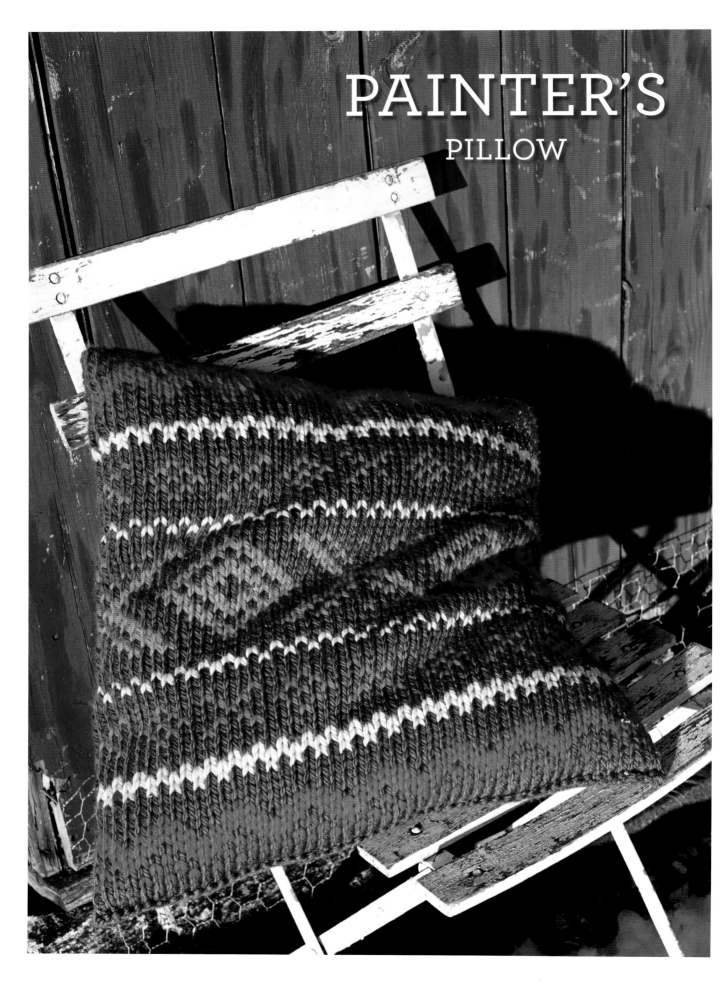

PAINTER'S
PILLOW

This pillow has the same colors as an old paint box.

FINISHED MEASUREMENTS
17¾ x 17¾ in / 45 x 45 cm

MATERIALS
Yarn: (CYCA #4), Rauma Vamse, 100% wool (91 yd/83 m / 50 g)
Yarn Amounts:
Color 1: Brown V64, 200 g
Color 2: Red V24, 50 g
Color 3: Blue V49, 50 g
Color 4: Orange V61, 50 g
Color 5: Purple V57, 50 g

NOTE: Hold 2 strands of yarn together throughout.

Needles: U.S. size 10½ / 6.5 mm: 32 in / 80 cm circular

Notions: Pillow form, 24 x 24 in / 60 x 60 cm. The finished pillow measures approx. 17¾ x 17¾ in / 45 x 45 cm, but we used a larger pillow form since a form the same size as the pillow cover flattens out with use. The larger form helps the pillow keep its shape and plumpness longer.

Gauge: 10 sts and 14 rows = 4 x 4 in / 10 x 10 cm. Adjust needle size to obtain correct gauge if necessary.

PILLOW
With 2 strands of Color 1 held together, CO 100 sts. Join, being careful not to twist cast-on row. Place marker for beginning of round. Work (P1, k49) 2 times. The cast-on row + the first row worked correspond to the first 2 rows of the chart. Continue, following the chart and working knit over knit and purl over purl, until 1 row remains on chart. BO with Color 1.

FINISHING
Weave in ends neatly on WS and then steam press pillow cover under a damp pressing cloth. With Color 1, seam one end of the pillow, making sure that the purl stitches are at the sides. Insert pillow form. Use Color 1 to seam the other end of the pillow and weave in remaining ends.

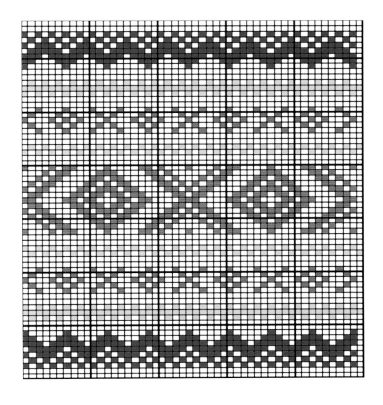

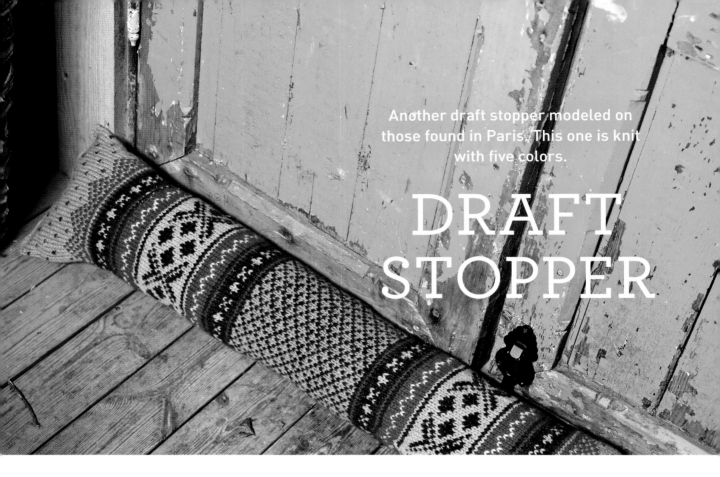

Another draft stopper modeled on those found in Paris. This one is knit with five colors.

DRAFT STOPPER

NOTE: The pattern repeat at each end of the draft stopper measures approx. 14¼ in / 36 cm. Measure your gauge and the space where the draft stopper will be used and then use that length to determine the number of pattern repeats needed. Work the lice in the center until the draft stopper is long enough. The first row of the lice pattern at the bottom of the chart = cast-on row.

FINISHED MEASUREMENTS

8¾ in / 22 cm wide x 37 in / 94 cm long. Work the panels as many times as needed for the draft stopper to be the right length for your window or door.

MATERIALS

Yarn: (CYCA #4), Rauma Vamse, 100% wool (91 yd/83 m / 50 g)

Yarn Amounts:
Color 1: Mustard V63, 100 g
Color 2: Brown V64, 100 g
Color 3: Red V23, 50 g
Color 4: Light Blue V50, 50 g
Color 5: White V01, 50 g

Needles: U.S. size 8 / 5 mm: 16 in / 40 cm circular

Notions: Fiber Fill from Coats

Gauge: 19 sts and 23 rows = 4 x 4 in / 10 x 10 cm. Adjust needle size to obtain correct gauge if necessary.

DRAFT STOPPER

With short circular and Color 1, CO 72 sts; join, being careful not to twist cast-on row. Place marker for beginning of round. Work around following the chart.

NOTE: The first row of the chart = cast-on row.

Continue in lice pattern to desired length (see Note above) and then work chart from the top down until 1 row remains. BO with Color 1.

FINISHING

Weave in all ends neatly on WS. Lightly steam press under a damp pressing cloth. Join seam at one end. Make a pillow form to fit the cover or stuff the draft stopper with fiber fill. Seam other opening.

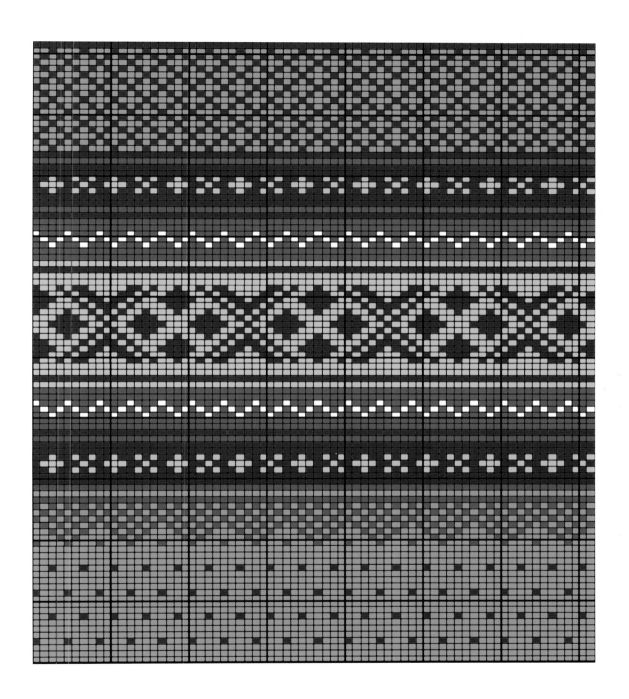

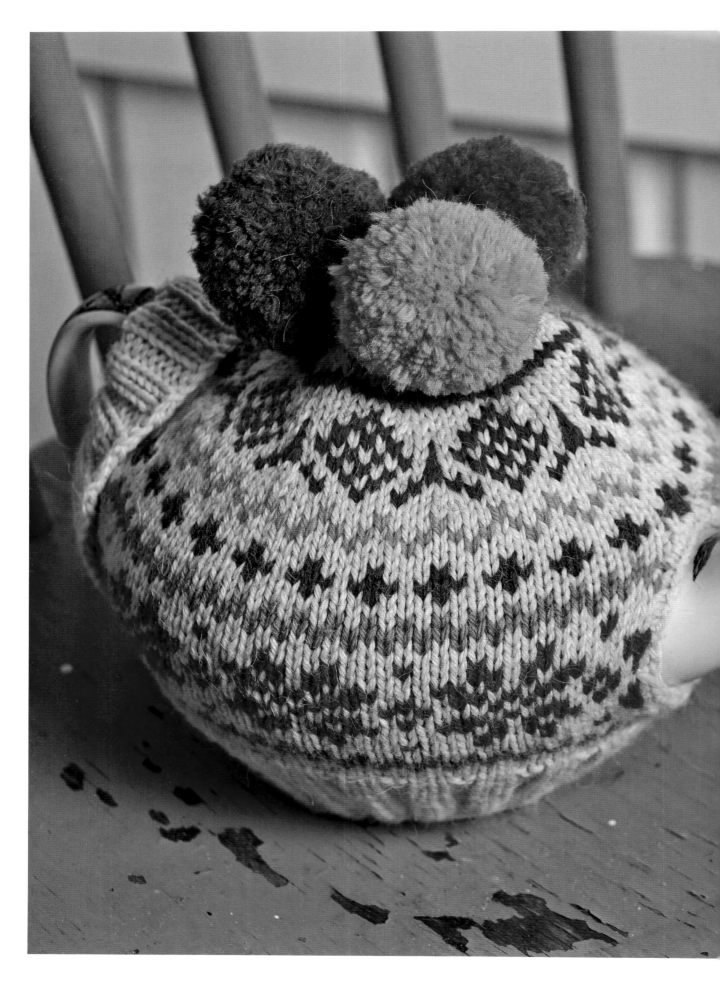

This tea cozy, knitted with Rauma Mitu yarn, was inspired by the colors on Grindley's Art Deco tea service, Pansy, from the 1930s. This one has eight-petaled roses that many perhaps don't consider as coming from Setesdal, but they were used for sweaters together with cross and ring. And it goes so nicely with the tea set.

TEA COZY

FINISHED MEASUREMENTS
Fits a 1 quart/liter tea pot

MATERIALS
Yarn: (CYCA #3), Rauma Mitu, 50% superfine alpaca and 50% wool yarn (109 yd/100 m / 50 g)
Yarn Amounts:
Color 1: Yellow 0184, 50 g
Color 2: Red 0042, 50 g
Color 3: Green, 6315, 50 g
Color 4: Purple 5090, 50 g
Color 5: Orange 0784, 50 g

Needles: U.S. sizes 2-3 and 4 / 3 and 3.5 mm: 16 in / 40 cm circulars and set of 4 or 5 dpn
Crochet hook: D-3 / 3 mm

Gauge: 22 sts and 28 rounds in stockinette on larger needles = 4 x 4 in / 10 x 10 cm.
Adjust needle sizes to obtain correct gauge if necessary.

TEA COZY
With smaller size circular and Color 1, CO 96 sts. Join, and place marker for beginning of rnd. Work in k2, p2 ribbing for 2 in / 5 cm. Change to larger size circular and work in pattern, following the chart, but after the first round divide sts in half, with 48 sts on each side. Work back and forth on each side separately for the next 16 rows of the chart. Place all the sts back on 1

circular and work back and forth in stockinette over all the sts for another 8 rows.

Now work in the round again and, *at the same time*, shape the top as follows:

Rnd 28: K96.

Rnd 29: *K2, (k2tog, k10) 3 times, k2tog, k8*; rep * to * once more.

Rnd 30: K88.

Rnd 31: *K2, (k2tog, k9) 3 times, k2tog, k7*; rep * to * once more.

Rnd 32: K80.

Rnd 33: *K2, (k2tog, k8) 3 times, k2tog, k6*; rep * to * once more.

Rnd 34: K72.

Rnd 35: *K3, (k2tog, k7) 3 times, k2tog, k4*; rep * to * once more.

Rnd 36: K64.

Rnd 37: *K3, (k2tog, k6) 3 times, k2tog, k3*; rep * to * once more.

Rnd 38: K56.

Rnd 39: *K3, (k2tog, k5) 3 times, k2tog, k2*; rep * to * once more.

Rnd 40: K48.

Rnd 41: *K3, (k2tog, k4) 3 times, k2tog, k1*; rep * to * once more.

Rnd 42: K40.

Rnd 43: (K3, k2tog) around.

Rnd 44: K32.

Rnd 45: (K2tog, k2) around.

Rnd 46: K24.

Cut yarn and draw end through rem 24 sts; pull tight and weave in on WS. Pull a bit on the strands around the openings for spout and handle so they lie smooth.

Opening for Spout: Work sc around smaller opening.

Opening for Handle: With Color 1 and smaller dpn, pick up and knit 68 sts around larger opening. Work in k2, p2 ribbing for 6 in / 15 cm. Fold the ribbing in half to RS and secure with a couple of stitches at lower edge.

Lightly steam press tea cozy under a damp pressing cloth, but do not press ribbing.

Optional: Make 3 pompoms and sew securely to top of cozy.

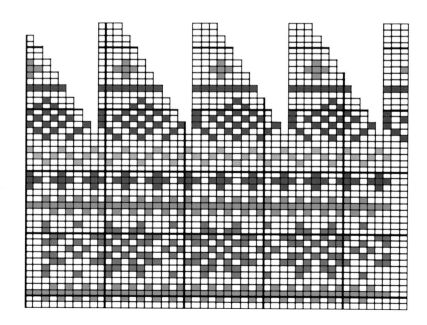

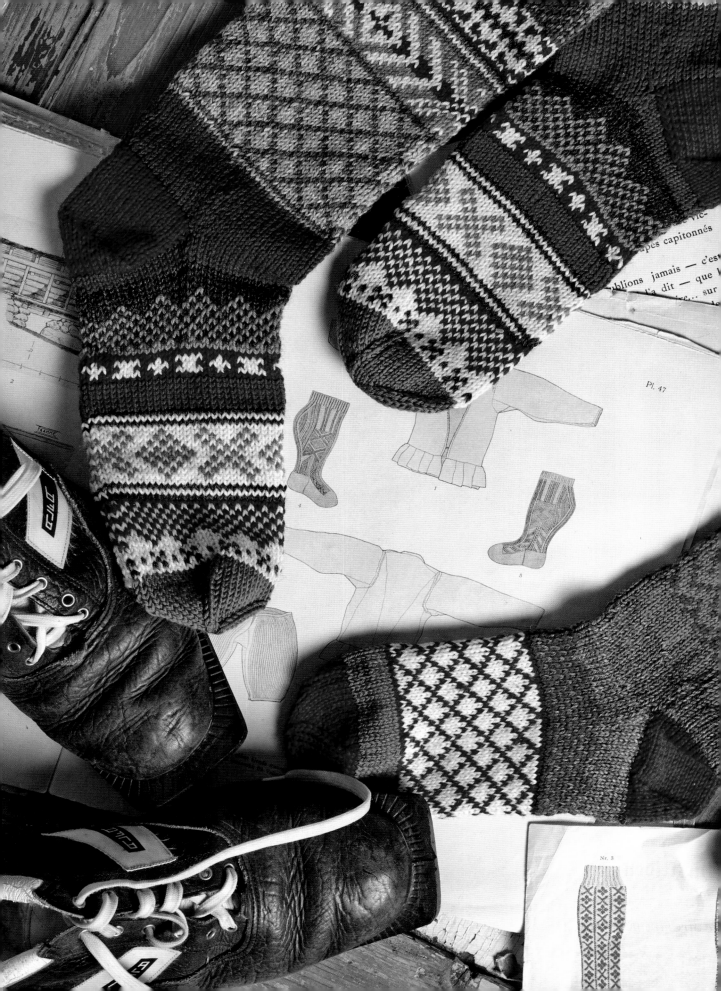

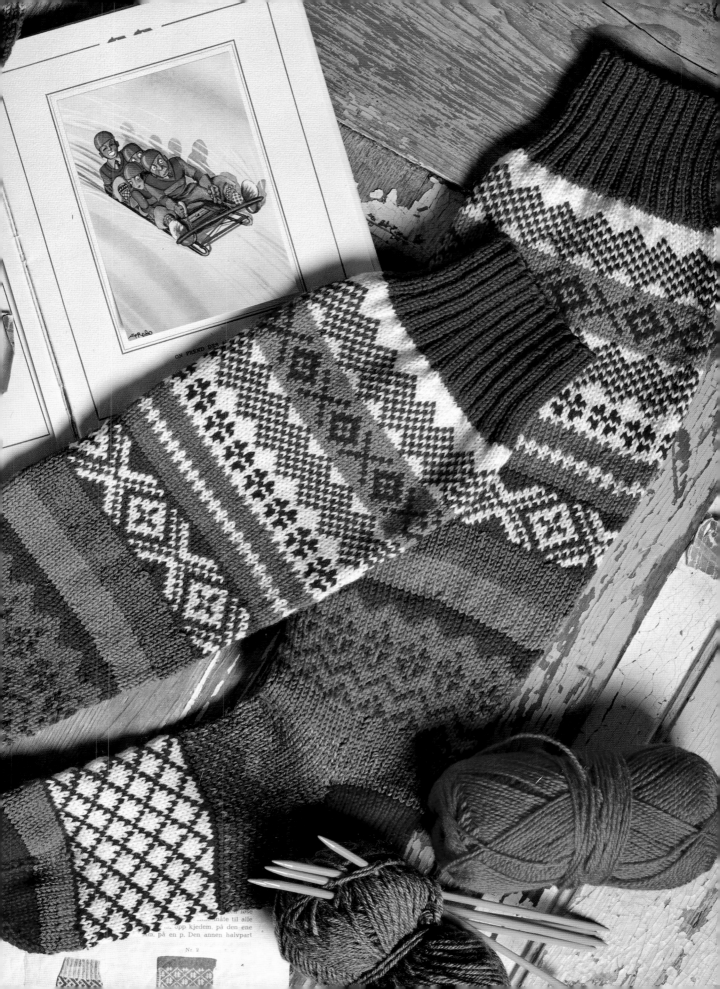

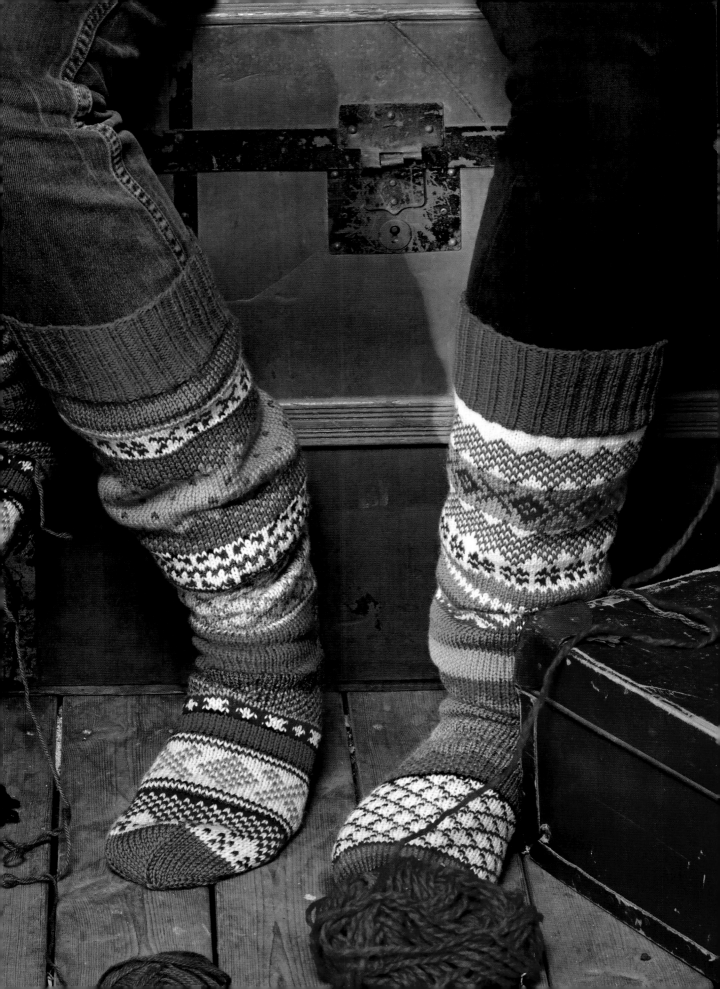

STOCKINGS

Stockings with panels inspired by various old pictures of Setesdal sweaters. For this type of design, we worked with a magnifying glass, pencil, and graph paper.

Cozy stockings for long winter days. These are good for wearing
with cold ski boots and will protect you from cold floors.

LONG
STOCKINGS

Stockings 1

FINISHED MEASUREMENTS
Total length leg to heel: 20 in / 51 cm
From heel to toe: 10¼ in / 26 cm
Measure your foot and add single color rnds if necessary for fit.

MATERIALS
Yarn: (CYCA #2), Rauma PT5, 80% wool, 20% nylon
(140 yd/128 m / 50 g)
Yarn Amounts:
Color 1: Blue 572, 100 g
Color 2: Green 588, 50 g
Color 3: Red 543, 50 g
Color 4: Mustard 516, 50 g
Color 5: White 503, 50 g
Color 6: Gray 504, 50 g
Color 7: Gray 510, 50 g

Needles: U.S. sizes 1-2 and 2-3 / 2.5 and 3 mm: set
of 5 dpn

Gauge: 26 sts and 33 rows in stockinette on larger
needles = 4 x 4 in / 10 x 10 cm.
Adjust needle sizes to obtain correct gauge if necessary.

STOCKINGS
With smaller size dpn and Color 1, CO 92 sts. Join,
being careful not to twist cast-on row. Divide sts over
4 dpn (= 23 sts per dpn) and work around in k2, p2
ribbing for 2½ in / 6 cm. Change to larger size dpn
and Color 2. Work 8 rnds in stockinette and, *at the
same time*, decrease 2 sts evenly spaced on first rnd =
90 sts. The round begins at center back. Now work in
pattern, following Chart 1. The patterning is reversed
at center front, so read the chart from left to right for
the second half of the round.

At A on the chart, decrease as follows: (K5, k2tog) 3
times; work until 21 sts rem and then (k2tog, k5) 3
times = 6 sts decreased and 84 sts rem.
At B, C, and D, decrease as follows: (K4, k2tog) 3
times; work until 18 sts rem and then (K2tog, k4) 3
times = 66 sts rem after last dec rnd.

After completing charted rows, divide the sts with
16 sts each on ndls 1 and 3 and 17 sts each on ndls
2 and 4. Work in stockinette with Color 1 for 1½ in / 4
cm, but, at ¾ in / 2 cm, decrease 4 sts around:
Ndls 1 and 2: Dec 1 st at beginning of needle.
Ndls 3 and 4: Dec 1 st at end of needle.
After dec rnd, 62 sts rem.

HEEL
With Color 3, work heel over sts on ndls 1 and 4 = 31
sts. Work back and forth in stockinette for 2¼ in / 5.5
cm. Slip the 1st st of each row purlwise for an edge
st. The last row = RS.

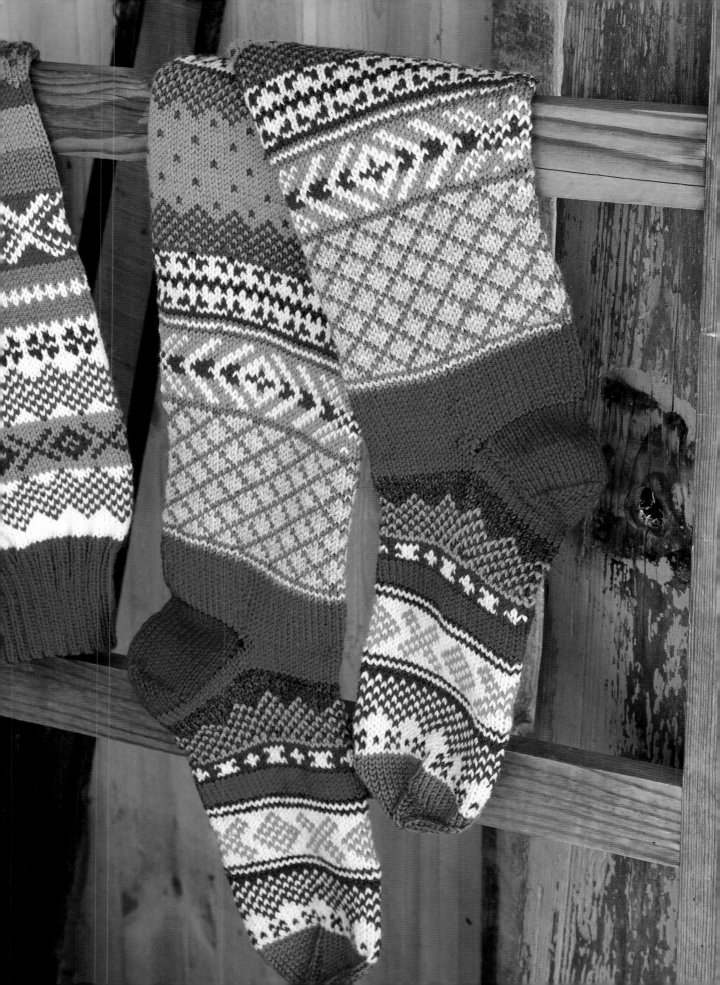

Heel Turn: Begin on WS: Work until 1 st past center st, p2tog, p1; turn. Work until 1 st past center st, ssk, k1; turn.

Now work until 1 st before gap, join (p2tog on WS, ssk on RS) the st before the gap with the st after gap, k1; turn. Continue the same way until all the sts outside the gap at each side have been used up = 17 sts rem. Divide heel sts onto 2 dpn with 9 sts on ndl 1 and 8 sts on ndl 4. The round now begins at center of sole.

FOOT

Change to Color 1 and knit 1 rnd stockinette, picking up and knitting 9 sts along edge sts on each side of heel = 35 sts on sole. Knit 2 more rnds. On 4th rnd, dec 1 st at end of ndl 1 and 1 st at beginning of ndl 4. Work in pattern, following Chart 2, reversing the pattern from center front so the second side of the stocking matches the first. Repeat the decreases on, alternately, the 4th and 14th rnds until 60 sts rem. When pattern is complete, continue in toe color (Color 2) until foot, as measured from back of heel, is approx. 9 in / 23 cm long. If you need to shorten the foot, omit the last pattern panel on the chart.

TOE

Change to Color 2 and knit 1 rnd. Now shape toe by *decreasing with k2tog at the end of each needle (= 4 dec per rnd). Knit 1 rnd. Repeat from * 2 more times. Now decrease on every rnd until 10 sts remain. Cut yarn and draw through rem sts and tighten. Weave in all ends neatly on WS.
Make second stocking the same way.

← D
← C
← B
← A

Chart 1

↑ Center front
↑ Center back

Chart 2

↑ Center front
↑ Center of sole

Stockings 2

FINISHED MEASUREMENTS
Total length leg to heel: 19 in / 48 cm
From heel to toe: 10¼ in / 26 cm
Measure your foot and add single color rnds if necessary for fit.

MATERIALS
Yarn: (CYCA #2), Rauma PT5, 80% wool, 20% nylon (140 yd/128 m / 50 g)
Yarn Amounts:
Color 1: Blue 572, 100 g
Color 2: White 502, 50 g
Color 3: Red 543, 50 g
Color 4: Green 588, 50 g
Color 5: Pink 548, 50 g
Color 6: Mustard 516, 50 g
Color 7: Gray 510, 50 g

Needles: U.S. sizes 1-2 and 2-3 / 2.5 and 3 mm: set of 5 dpn

Gauge: 26 sts and 33 rows in stockinette on larger needles = 4 x 4 in / 10 x 10 cm.
Adjust needle sizes to obtain correct gauge if necessary.

STOCKINGS
With smaller size dpn and Color 1, CO 92 sts. Join, being careful not to twist cast-on row. Divide sts over 4 dpn (= 23 sts per dpn) and work around in k2, p2 ribbing for 2½ in / 6 cm. Change to larger size dpn and begin Chart 1 (page 103). On the 1st rnd, decrease 2 sts evenly spaced around = 90 sts. The round begins at center back. The patterning is reversed at center front, so read the chart from left to right for the second half of the round.

At A on the chart, decrease as follows: (K5, k2tog) 3 times; work until 21 sts rem and then (k2tog, k5) 3 times = 6 sts decreased and 84 sts rem.
At B, C, and D, decrease as follows: (K4, k2tog) 3 times; work until 18 sts rem and then (K2tog, k4) 3 times = 66 sts rem after last dec rnd.

Change to color 7 and knit 1 rnd. On the next rnd, decrease: (K4, k2tog) 3 times. Work until 18 sts rem and work (k2tog, k4) 3 times = 60 sts rem.

HEEL
With Color 3, work heel over sts on ndls 1 and 4 = 29 sts. Work back and forth in stockinette for 2¼ in / 5.5 cm. Slip the 1st st of each row purlwise for an edge st. The last row = RS.

Heel Turn: Begin on WS: Work until 1 st past center st, p2tog, p1; turn. Work until 1 st past center st, ssk, k1; turn.
Now work until 1 st before gap, join (p2tog on WS, ssk on RS) the st before the gap with the st after gap, k1; turn. Continue the same way until all the sts outside the gap at each side have been used up = 17 sts rem. Divide heel sts onto 2 dpn with 9 sts on ndl 1 and 8 sts on ndl 4. The round now begins at center of sole.

FOOT
Change to color 7 and knit 1 rnd stockinette, picking up and knitting 9 sts along edge sts on each side of heel = 35 sts on sole. Knit 6 more rnds, decreasing 1 st at each side of sole on Rnds 1, 4, and 7 = 60 sts rem.
Work in pattern, following Chart 2 (page 103) and reversing the pattern from center front so the second side of the stocking will match the first. At A on the chart, dec 1 st on each side of the sole. When pattern is complete, foot, as measured from back of heel, is approx. 8¾ in / 22 cm long. Divide sts so 2 ndls have 15 sts each and 2 ndls have 14 sts each.

TOE
Change to Color 3 and knit 1 rnd. Now shape toe by *decreasing with k2tog at the end of each needle (= 4 dec per rnd). Knit 1 rnd. Repeat from * 2 more times. Now decrease on every rnd until 10 sts remain. Cut yarn and draw through rem sts and tighten. Weave in all ends neatly on WS.

Make second stocking the same way.

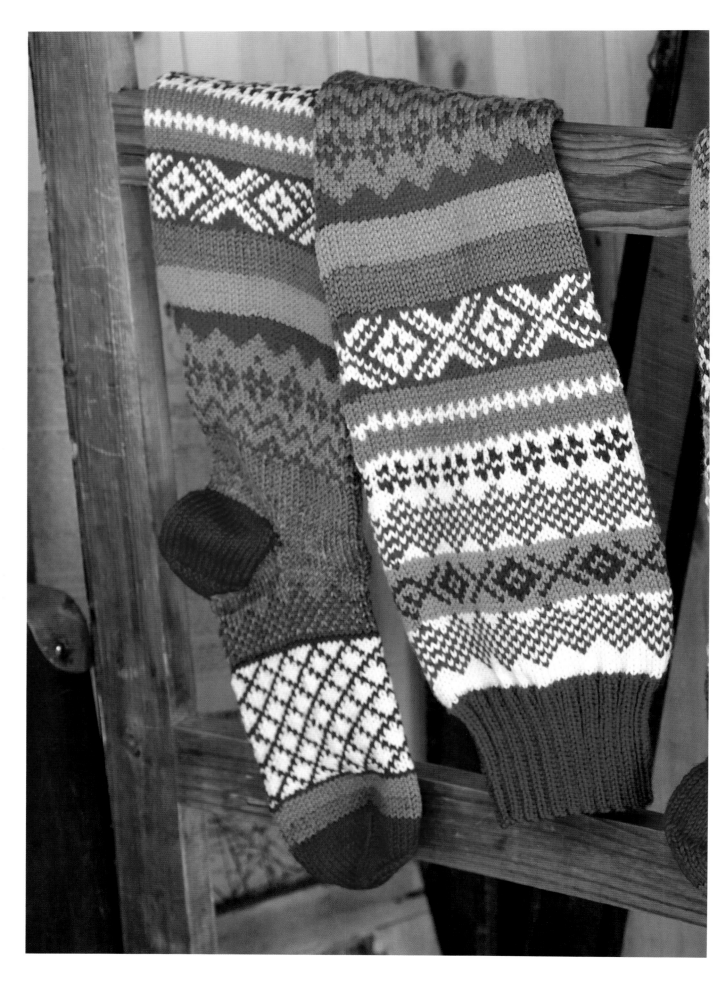

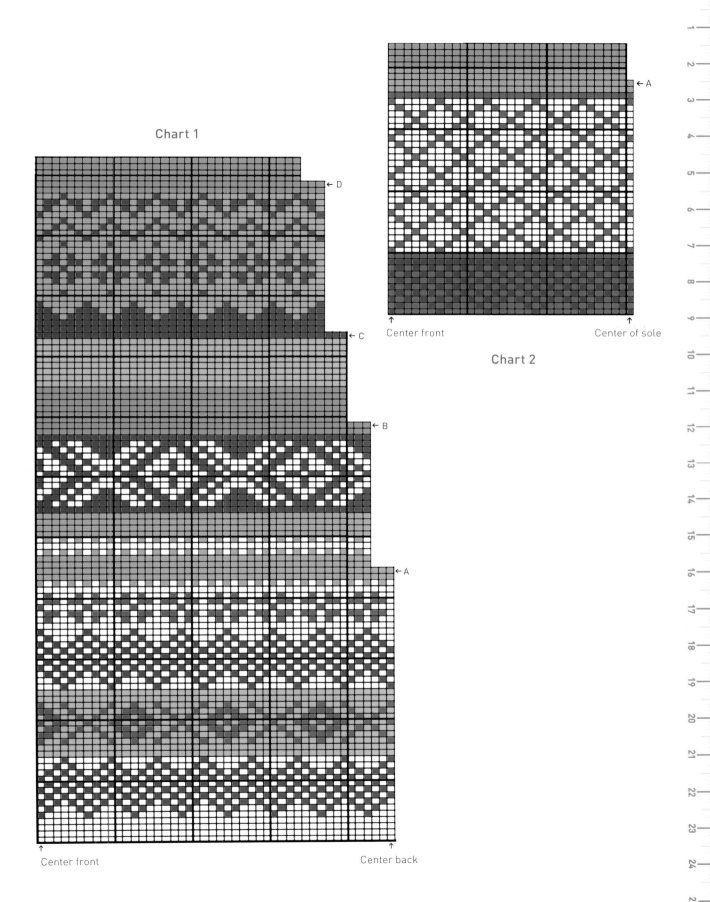

Chart 1

Chart 2

← D

← C

← B

← A

← A

Center front

Center of sole

Center front

Center back

"*Legging Socks: a sock
that reaches down to
the instep and heel but
without a knitted foot.*"

Gamalt or Setesdal III

LEG WARMERS

FINISHED MEASUREMENTS
Widest Circumference: 14¼ in / 36 cm
Length: 24½ in / 62 cm long

MATERIALS
Yarn: (CYCA #3), Rauma Mitu, 50% superfine alpaca and 50% wool yarn (109 yd/100 m / 50 g)
Yarn Amounts:
Color 1: Blue 4922, 250 g
Color 2: Red 0042, 50 g
Color 3: Orange 0784, 50 g
Color 4: Green 6315, 50 g
Color 5: White SNF10, 50 g

Needles: U.S. sizes 2-3 and 4 / 3 and 3.5 mm: set of 4 or 5 dpn

Gauge: 22 sts and 28 rounds in stockinette on larger needles = 4 x 4 in / 10 x 10 cm.
Adjust needle sizes to obtain correct gauge if necessary.

With smaller size dpn and Color 1, CO 80 sts. Join, being careful not to twist cast-on row. Divide sts evenly over 4 dpn (= 20 sts per needle) and work around in k2, p2 ribbing for 6¼ in / 16 cm. Change to larger size dpn and work charted pattern, working repeat between arrows 4 times. On the 1st rnd, increase 5 sts evenly spaced around = 85 sts. Work charted rows once, always working repeat between arrows 4 times. Decrease as indicated on chart every 9 rnds = a total of 10 dec rnds = 65 sts rem. Work decreases as k2tog. After completing charted rows, increase 11 sts evenly spaced around = 76 sts. Change to smaller dpn and, continuing with Color 1, work in k2, p2 ribbing for 2 in / 5 cm. BO loosely. Weave in all ends neatly on WS. Lightly steam press leg warmers under a damp pressing cloth but do not press ribbing.

These leg warmers are designed so that the long ribbing is at the top and can be folded down. However, you can also wear them the opposite way. If you need extra warmth around your ankles and aren't wearing shoes, try the long ribbing at ankles as shown in the photo. If you are wearing shoes, it is best to have the short band of ribbing at your ankle so the leg warmers will fit nicely around the top of your shoes.

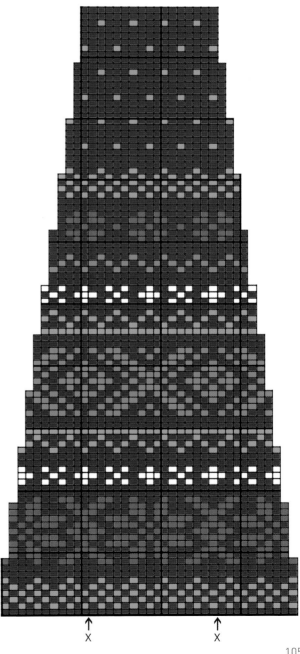

X X

My grandmother

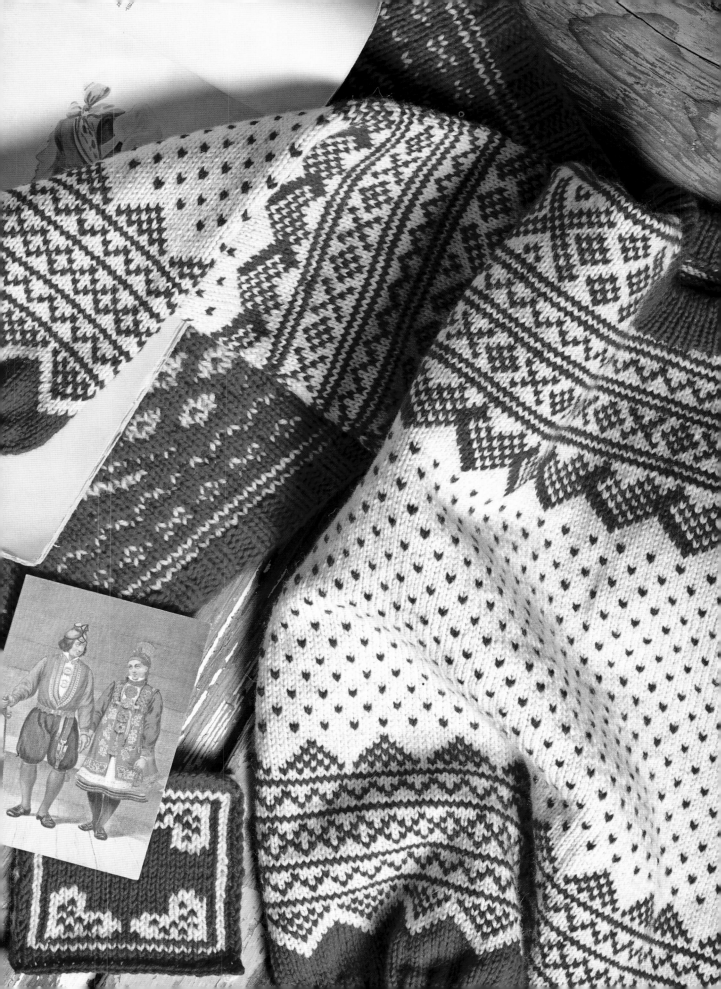

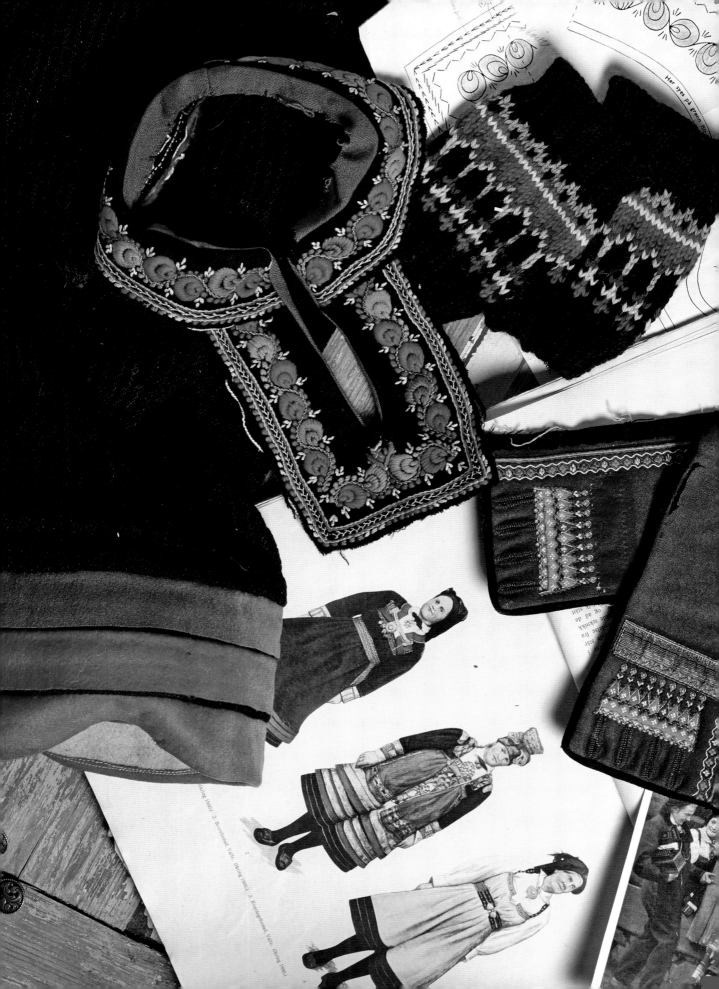

(kring 1844) 2. Bormhund Valle- (kring 1844) 3. Kordagshumst, Valle (kring 1844)

GRANDMOTHER

In the wedding photos of Arne's parents, Grandmother Torbjørg is wearing a Setesdal sweater that appears to have hearts at the sawtooth/half crown edges. This image inspired the hearts in our Setesdal panels.

"The bride wore a red skirt. She had on four skirts underneath, the first a white skirt made of vadmal, *then two blue skirts and, on top, the red cloth skirt."*

Johannes Skar, *Gamalt or Setesdal II*

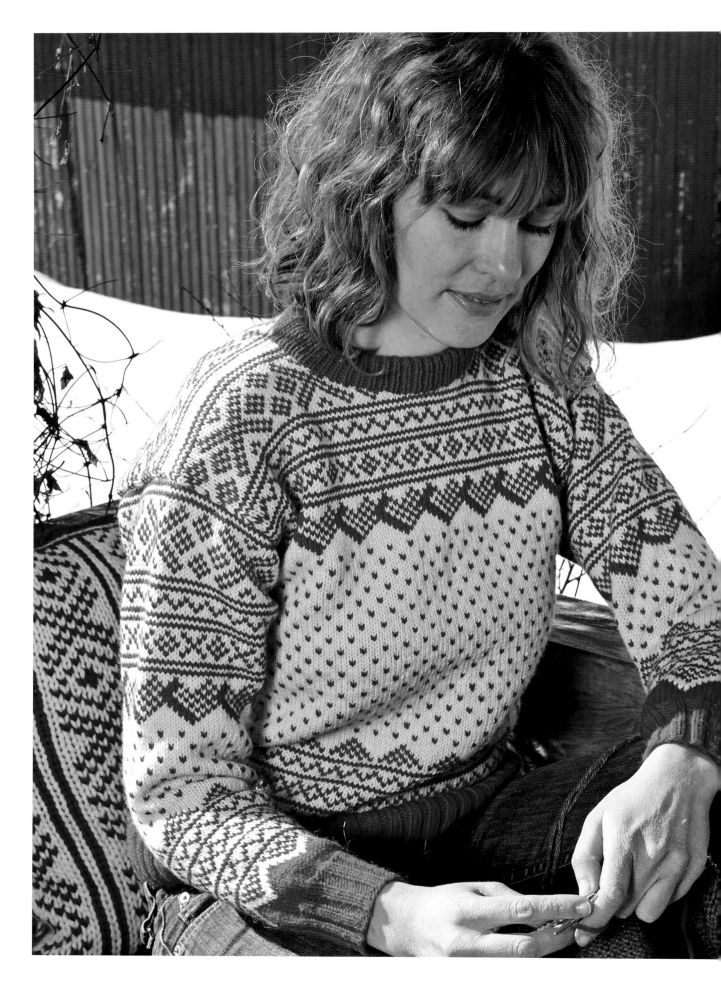

SWEATER
WITH HEARTS

SIZES
Women's S (M, L, XL)

FINISHED MEASUREMENTS
Chest: 36 (39½, 43, 46½) in / 91 (100, 109, 118) cm
Total length: 23¾ (23¾, 24½, 25¼) in / 60 (60, 62, 64) cm
Sleeve length: 18¼ (18½, 19, 19¼) in / 46 (47, 48, 49) cm

MATERIALS
Yarn: (CYCA #3), Rauma Mitu, 50% superfine alpaca
and 50% wool yarn (109 yd/100 m / 50 g)
Yarn Amounts:
Color 1: Red 0042, 250 (250, 300, 350) g
Color 2: White SFN10, 350 (400, 400, 450) g

Needles: U.S. sizes 2-3 and 4 / 3 and 3.5 mm: circulars
and set of 5 dpn

Gauge: 22 sts and 28 rounds in stockinette on larger
needles = 4 x 4 in / 10 x 10 cm.
Adjust needle sizes to obtain correct gauge if
necessary.

BODY
With smaller size circular and Color 1, CO 200 (220,
240, 260) sts. Join, being careful not to twist cast-on
row; place marker for beginning of round. Work around
in k2, p2 ribbing for 2½ in / 6 cm. Change to larger size
circular. Begin Chart 1 pattern at arrow for your size.
After pattern panels, work in lice pattern until sweater
measures approx. 16¼ (16¼, 17, 17¾) in / 41 (41, 43, 45)
cm. Place a marker at each side = 100 (110, 120, 130)
sts each for front and back. Work patterns on Chart 2,
beginning at arrow for your size and then knit to side
marker = front. Repeat on the back. When pattern is
complete, place sts of front and back each on separate
holders.

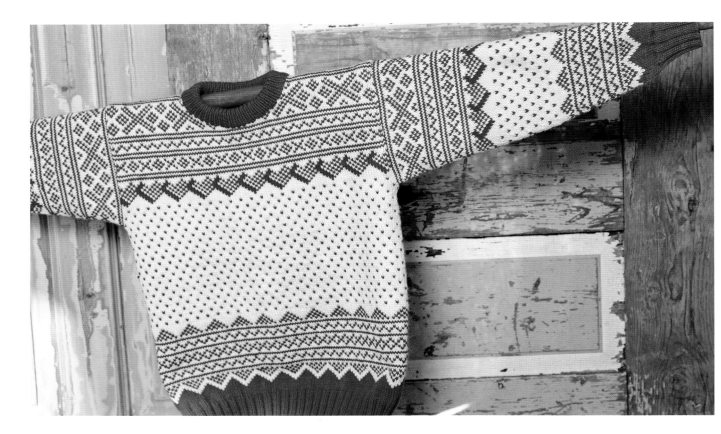

SLEEVES

With smaller size dpn and Color 1, CO 48 (48, 52, 52) sts. Join, being careful not to twist cast-on row; place marker for beginning of round. Work around in k2, p2 ribbing for 2½ in / 6 cm. On the last rnd of ribbing, inc 7 sts evenly spaced around = 55 (55, 59, 59) sts. Change to larger size dpn. Begin Chart 1 pattern at arrow for your size. Count out from the X on the chart and make sure the pattern is centered on sleeve. Every ¾ in / 2 cm, increase 2 sts at center of underarm until there are 89 (93, 97, 101) sts. Increase as follows: K1, M1R, knit until 1 st rem, M1L, k1. Work new sts in to pattern.

After pattern panels are complete, work in lice pattern until sleeve is approx. 10¾ (11, 11½, 11¾) in / 27 (28, 29, 30) cm long and you've worked 2 rnds past the last lice round. Now work in pattern, following Chart 2 and making sure pattern is centered on the sleeve (count out from X on chart). Finish by turning sleeve inside out and working in stockinette for ¾ in / 2 cm for facing, *at the same time* increasing 2 sts at center of underarm on every other rnd.

SLEEVE AND NECK FINISHING

Lay the sleeve flat and measure the width of the sleeve just below the facing. Mark the sleeve width at each side of the body down from the shoulder. The first and last sts of the front and back are the side sts. Machine-stitch 2 lines down between the markers and then cut the armholes open between stitch lines.

Mark the neck opening by hand basting the neckline. The neck opening should be 7 (7½, 8, 8¼) in / 18 (19, 20, 21) cm wide, 2¾ in / 7 cm deep at center front, and ¾ in / 2 cm deep at center back. Round the neckline smoothly, making sure that the patterns match on both sides. Machine-stitch 2 lines inside the basting threads and then cut away excess fabric above stitching, leaving a small seam allowance. Join shoulders either with Kitchener stitch or 3-needle bind-off.

NECKBAND

With smaller size circular and Color 1, pick up and knit approx. 100 (104, 108, 112) sts around neck. Work around in k1, p1 ribbing for 2 in / 5 cm. BO loosely. Fold neckband and sew down by hand on WS to cover cut edges.

Attach sleeves. Fold facing over cut edges and sew down on WS.

Chart 1

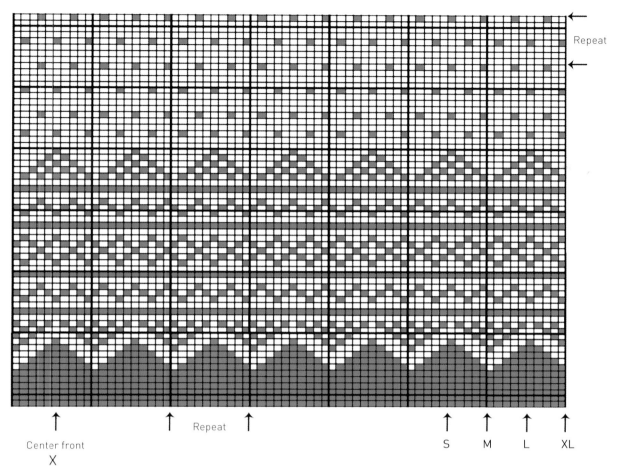

Repeat

↑ Center front
X

↑ Repeat ↑

↑ S ↑ M ↑ L ↑ XL

Chart 2

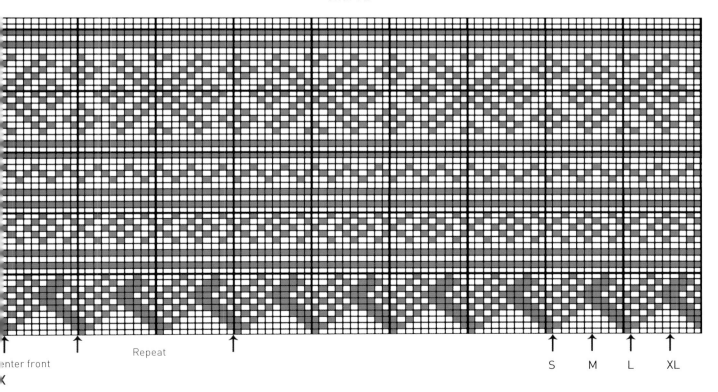

Center front
X

↑ Repeat

↑

↑ S ↑ M ↑ L ↑ XL

Hearts are also suitable for Christmas. Why not knit a skirt decorated with crosses, rings, and hearts to set under the Christmas tree stand so it won't mark the floor?

CHRISTMAS TREE
SKIRT

FINISHED MEASUREMENTS

The skirt measures 27½ x 27½ in / 70 x 70 cm after blocking. This will vary depending on how much you have to block out the piece to make it lay flat.

MATERIALS

Yarn: (CYCA #1), Rauma Finullgarn, 100% wool (191 yd/175 m / 50 g)
Yarn Amounts:
Color 1: White 401, 200 g
Color 2: Red 424, 300 g

NOTE: Hold 2 strands of yarn together throughout.

Needles: U.S. size 7 / 4.5 mm: set of 5 dpn and short circular; U.S. size 9 / 5.5 mm: long circular

Gauge: 15 sts and 26 rounds in stockinette on larger needles = 4 x 4 in / 10 x 10 cm.
Adjust needle sizes to obtain correct gauge if necessary.

CHRISTMAS TREE SKIRT

With Color 2 and smaller size dpn, CO 16 sts. Divide sts evenly over 4 dpn and join. The reason we begin knitting with smaller size needles is that single-color quickly becomes looser than 2-color pattern knitting. Working the skirt this way helps the piece keep its shape during blocking.

Work around in stockinette, increasing as follows:
Rnd 1: K16.
Rnd 2: (Yo, k1, M1, k2, M1, k1) around = 28 sts.
Rnd 3: (P1 into yarnover, k6, yo) around = 32 sts.
Rnds 4-5: Knit.
Rnd 6: (Yo, k1, M1, k6, M1, k1) around = 44 sts.
Rnd 7: (P1 into yarnover, k10, yo) around = 48 sts.
Rnds 8-9: Knit.
Rnd 10: (Yo, k1, M1, k10, M1, k1) around = 60 sts.
Rnd 11: (P1 into yarnover, k14, yo) around = 64 sts.
Rnds 12-13: Knit.
Rnd 14: (Yo, k1, M1, k14, M1, k1) around = 76 sts.
Rnd 15: (P1 into yarnover, k18, yo) around = 80 sts.
Rnds 16-17: Knit.
Rnd 18: (Yo, k1, M1, k18, M1, k1) around = 92 sts.
Rnd 19: (P1 into yarnover, k22, yo) around = 96 sts.
Rnds 20-21: Knit.
Rnd 22: (Yo, k1, M1, k22, M1, k1) around = 108 sts.
Rnd 23: (P1 into yarnover, k26, yo) around = 112 sts.
Rnds 24-25: Knit.
Rnd 26: (Yo, k1, M1, k26, M1, k1) around = 124 sts.
Rnd 27: (P1 into yarnover, k30, yo) around = 128 sts.
Rnds 28-29: Knit.
Rnd 30: (Yo, k1, M1, k30, M1, k1) around = 140 sts.
Rnd 31: (P1 into yarnover, k34, yo) around = 144 sts.
Rnds 32-33: Knit.
Rnd 34: (Yo, k1, M1, k34, M1, k1) around = 156 sts.

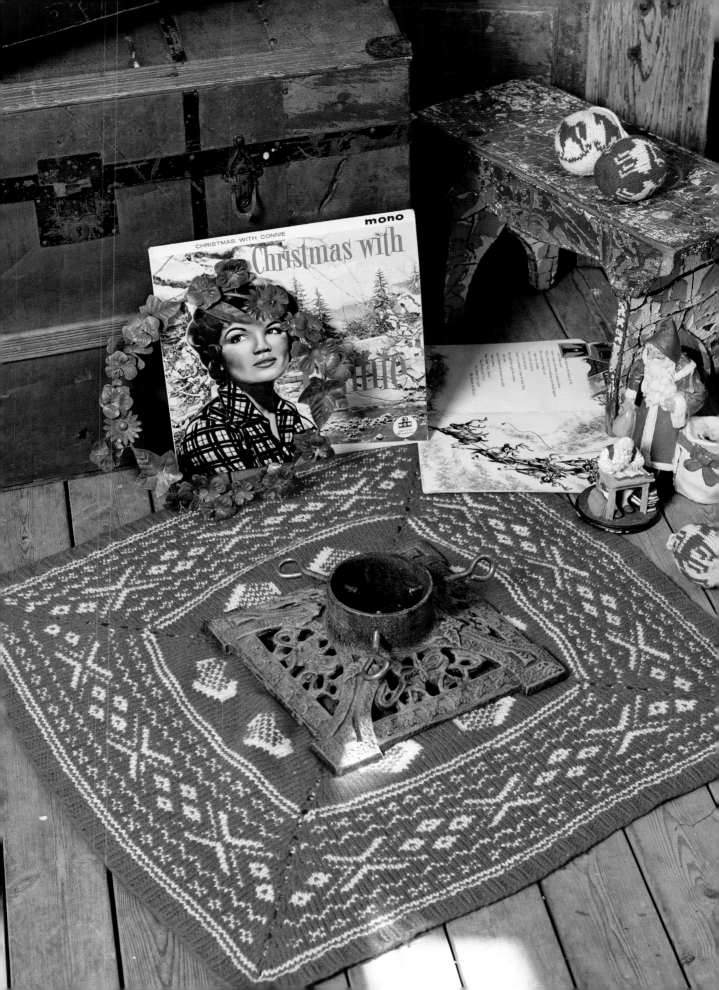

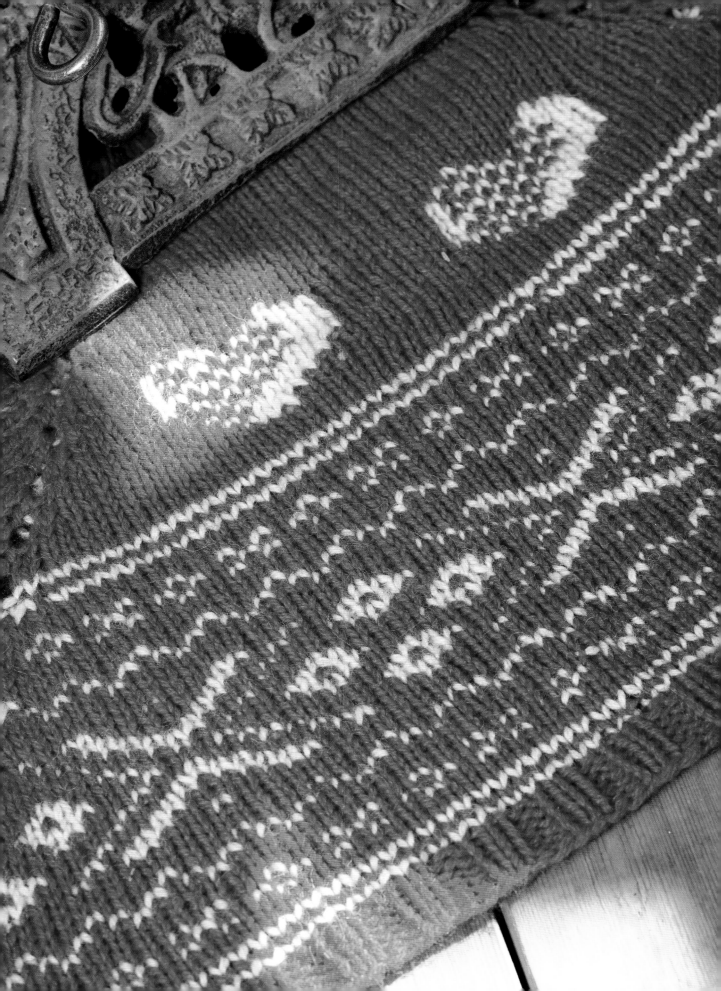

Change to larger size circular.

Rnd 35 (= bottom row of chart): (P1 into yarnover, k38, yo) around = 160 sts.

Now work following the chart, increasing on every 4th rnd. The chart is repeated 4 times on each round.

Finish with 5 rnds k2, p2 ribbing. **NOTE:** Ribbing is worked on larger size needle so the cloth will lie flat. BO loosely. Use cast-on tail to close the hole at the center and then weave in all ends neatly on WS.

Lightly dampen the cloth and stretch it over an ironing board. Pin the corners and lightly steam press on RS.

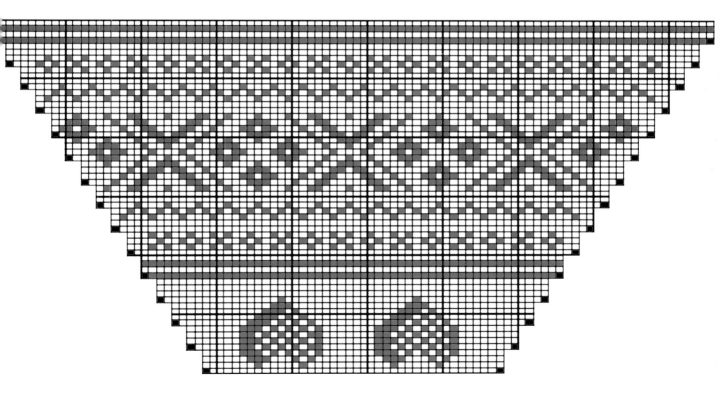

DOG SWEATER

The ribbing on the body is worked with the same size needles as for the two-color patterning because it doesn't have to stretch around the dog's body. It just helps the sweater lie smoothly over the back. We knitted up two sweaters with different size needles and gauge but with the same yarn. The small sweater fits Freja, who weighs 13.2 pounds / 6 kilos; the larger sweater fits her mother. To make sure the sweater will fit your dog, make a large gauge swatch and check measurements.

SIZES
S (L)

FINISHED MEASUREMENTS
Measure around your dog's stomach and knit a gauge swatch. Check the gauge measurements against the dog you are knitting for. If your dog is large, you might be able to use the same pattern but with Vamse yarn. The small size sweater measures 15¾ in / 40 cm around the stomach and is 11 in / 28 cm long, excluding the ribbing around the neck.

MATERIALS
Yarn: (CYCA #3), Rauma Mitu, 50% superfine alpaca and 50% wool yarn (109 yd/100 m / 50 g)
Yarn Amounts:
Color 1: Gray SFN41, 150 g
Color 2: Pink 1332, 50 g

Needles:
Small sweater: U.S. size 4 / 3.5 mm: circular; U.S. sizes 2-3 and 4 / 3 and 3.5 mm: set of 5 dpn.

Large sweater: U.S. size 6 / 4 mm: circular; U.S. sizes 4 and 6 / 3.5 and 4 mm: set of 5 dpn.

Gauge:
Small sweater: 26 sts and 32 rows in stockinette on larger needles = 4 x 4 in / 10 x 10 cm.
Large sweater: 20 sts and 25 rows in stockinette on larger needles = 4 x 4 in / 10 x 10 cm.
Adjust needle sizes to obtain correct gauge if necessary.

SWEATER
With Color 1 and short circular U.S. size 4 (6) / 3.5 (4) mm, CO 86 sts. Work the ribbing back and forth as follows:
Row 1: Work P2, k2 across to last 2 sts and end with p2.
Row 2: Work K2, p2 across to last 2 sts and end with k2.
Repeat these 2 rows until you've worked 10 rows total.

Continue back and forth in stockinette, shaping the lower edge as follows:
Row 1: P43, M1p, p18; turn.
Work back and forth in stockinette short rows:
Row 2: K37.
Row 3: P38.
Row 4: K39.
Continue in stockinette, with 1 more stitch on each row until 15 sts rem on WS. Turn work and knit across all sts. Now work in stockinette, shaping piece as follows:
Row 1: Purl.

Row 2: K1, M1, work until 2 sts rem and end M1, k2. Repeat these 2 rows until there are a total of 103 sts. Now join the sweater and knit in the round, following Chart 1.

On Rnd 1, inc with M1 inside the 1st st of the row = 104 sts. On the last row of Chart 1, shape leg openings: K7, BO 10 sts loosely, k71 (including last st of bind-off), BO 10 sts loosely, k6 (including last st of bind-off). Place sts on a holder and work the legs.

LEGS

With Color 1 and dpn U.S. size 4 (6) / 3.5 (4) mm, CO 40 sts. Divide sts onto 4 dpn, join and work 5 rnds k2, p2 ribbing. Next, work following Chart 2 and, on the last rnd, BO 5 sts loosely, k30 (including last st of bind-off), BO 5 loosely.

Knit the second leg the same way.

Joining Legs and Body

Join the legs and body while starting Chart 3 pattern as follows:

Rnd 1: Beginning at center front, k7 from body, k30 from first leg, placing it over first gap in body; k71 for back, k30 of second leg, placing it over second gap in body; and then k6 of body = 144 sts total.

Rnd 2: K4, k2tog, k2, k2tog, k11, k2tog, k11, k2tog, k73, k2tog, k11, k2tog, k11, k2tog, k2, k2tog, k3 = 136 sts rem.

Rnd 3: Knit.

Rnd 4: K3, k2tog, k25, k2tog, k73, k2tog, k25, k2tog, k2 = 132 sts rem.

Rnd 5: Knit.

Rnd 6: K2, k2tog, k2, k2tog, k20, k2tog, k73, k2tog, k20, k2tog, k2, k2tog, k1 = 126 sts rem.

Rnd 7: Knit.

Rnd 8: K1, k2tog, k2, k2tog, k18, k2tog, k73, k2tog, k18, k2tog, k2, k2tog = 120 sts rem.

Rnd 9: Knit.

Rnd 10: K2tog, k2, k2tog, k16, k2tog, k73, k2tog, k16, k2tog, k1, k2tog = 114 sts rem.

Rnd 11: Knit.

Rnd 12: K3, k2tog, k14, k2tog, k73, k2tog, k14, k2tog, k2 = 110 sts rem.

Rnd 13: Knit.

Rnd 14: K3, k2tog, k12, k2tog, k2, k2tog, k65, k2tog, k2, k2tog, k12, k2tog, k2 = 104 sts rem.

Rnd 15: Knit.

Rnd 16: K3, k2tog, k10, k2tog, k2, k2tog, k63, k2tog, k2, k2tog, k10, k2tog, k2 = 98 sts rem.

Rnd 17: Knit.

Rnd 18: K1, k2tog, knit to last 3 sts and end k2tog, k1 = 96 sts rem.

Change to smaller size dpn, and work in k2, p2 ribbing for 6 in / 15 cm.

FINISHING

Seam gap under legs and then weave in all ends neatly on WS.

Lightly steam press sweater under a damp pressing cloth, but do not press ribbing.

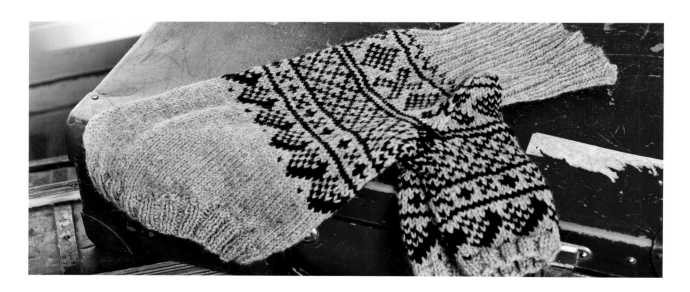

Chart 1—Body

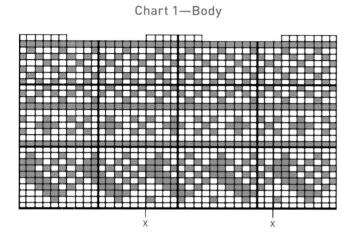

X X

Chart 2—Legs

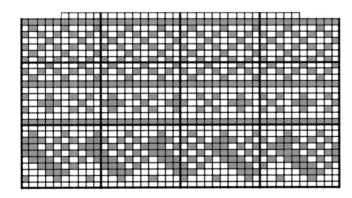

Chart 3—Raglan seam legs and body

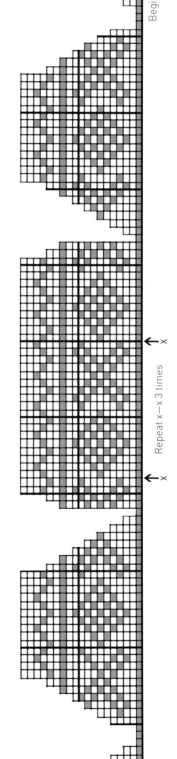

Begin here

←X

Repeat x–x 3 times

←X

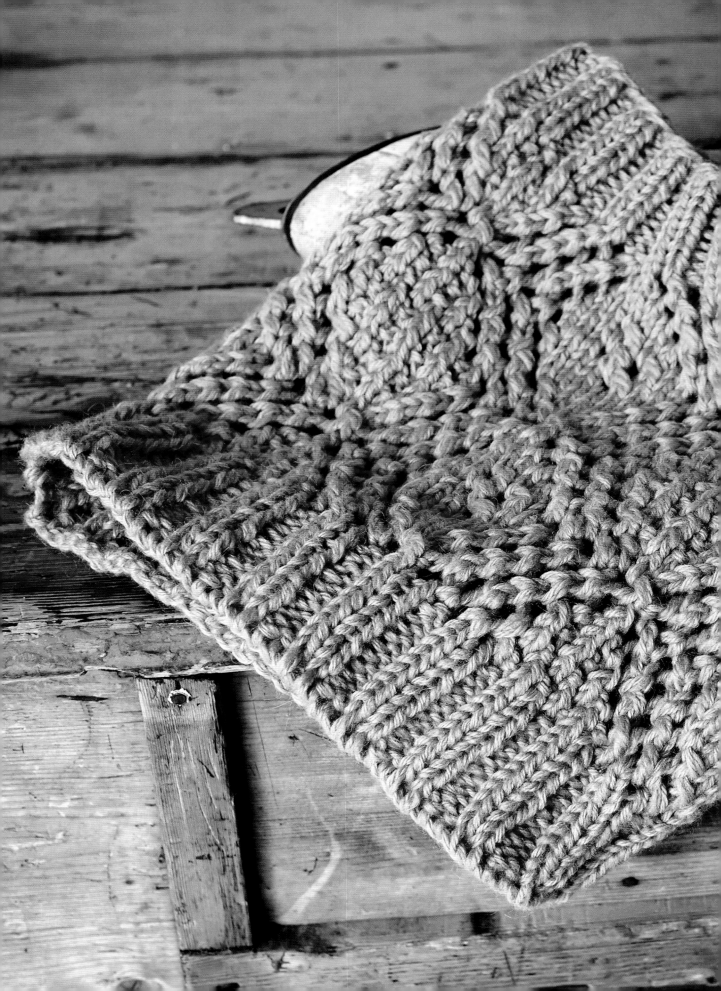

RELIEF STITCH PATTERNS AND DOUBLE KNITTING

Relief stitch patterns were commonly knitted on Setesdal stockings for the costume. There are many motifs used on the *krotasokker*, or decorative stockings. We've used relief stitch patterns for a blanket and a neck warmer.

"'Now you have been nice, so you shall get some six-stitch herringbone patterns,' she said."

Free translation of the Norwegian from *Gamalt or Setesdal I*

CHAPTER 9

If you knit the blanket the same size as given in the instructions below, you'll have a lovely blanket for the baby's room. If you want a throw to keep your shoulders or knees warm, increase the number of repeats to make the blanket bigger.

HERRINGBONE PATTERN
BLANKET

FINISHED MEASUREMENTS
47¼ x 59 in / 120 x 150 cm

MATERIALS
Yarn: (CYCA #4), Rauma Vamse, 100% wool (91 yd/83 m / 50 g)
Yarn Amounts:
White V01, 750 g

Needles: U.S. size 8 / 5 mm: 32 or 40 in / 80 or 100 cm circular

Gauge: 15 sts and 20 rows = 4 x 4 in / 10 x 10 cm. Adjust needle size to obtain correct gauge if necessary.

BLANKET
NOTE: If you want a larger blanket, add 17 or 34 extra sts. Because the repeat is 17 sts, always add in multiples of 17. Don't forget to buy extra yarn if you want to make a larger blanket.

The blanket is worked back and forth. Always slip the first st of every row purlwise with yarn held behind. The last 4 sts of every row are knit.

CO 161 sts and work 5 rows garter stitch (knit every row). Now work in herringbone pattern (1 repeat = 17 sts).

Row 1: Sl 1, k3, *p4, k4, yo, k3, ssk, p4*; rep * to * until 4 sts rem and end with k4.
Row 2: Sl 1, k3, p153, k4.
Row 3: Sl 1, k3, *p3, k2tog, k3, yo, k1, yo, k3, ssk, p3*; rep * to * until 4 sts rem and end with k4.
Row 4: Sl 1, k3, p153, k4.
Row 5: Sl 1, k3, *p2, k2tog, k3, yo, k3, yo, k3, ssk, p2*; rep * to * until 4 sts rem and end with k4.
Row 6: Sl 1, k3, p153, k4.
Row 7: Sl 1, k3, *p1, k2tog, k3, yo, k5, yo, k3, ssk, p1*; rep * to * until 4 sts rem and end with k4.
Row 8: Sl 1, k3, p153, k4.
Row 9: Sl 1, k3, *k2tog, k3, yo, k7, yo, k3, ssk*; rep * to * until 4 sts rem and end with k4.
Row 10: Sl 1, k3, p153, k4.

Repeat these 10 rows 29 times for a total of 30 pattern repeats.

Finish with 5 rows garter st. BO loosely. Weave in ends and then block blanket.

Slip 1 (sl 1) knitwise—slide the stitch to the right needle as if to knit but without knitting it.

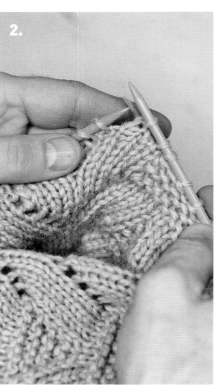

Knit 2 sts together.

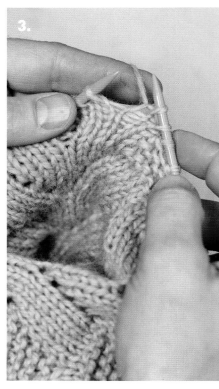

One knit stitch.

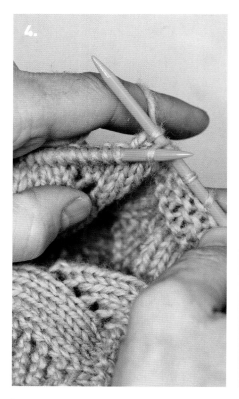

Pass the slipped stitch over the 2 sts knitted together (= double decrease).

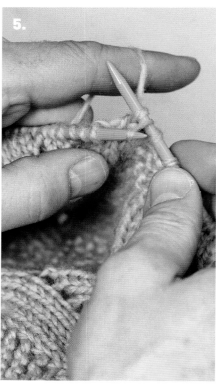

Pass the slipped stitch over the 1 knitted stitch.

Yarnover (yo): you can increase 1 stitch by bringing the yarn over the needle before you work the next st.

NECK WARMER
IN RELIEF STITCH KNITTING

A general rule for relief stitch knitting: every time you k2tog you also have to increase 1 st, and vice versa. Every increase is paired with a decrease.

FINISHED MEASUREMENTS
13 in / 33 cm high and 24½ in / 62 cm circumference

MATERIALS
Yarn: (CYCA #4), Rauma Vamse, 100% wool (91 yd/ 83 m / 50 g) and (CYCA #3), Rauma Mitu, 50% super-fine alpaca and 50% wool yarn (109 yd/100 m / 50 g)
Yarn Amounts:
Vamse Pink V60, 100 g
Mitu Pink 1832, 100 g

Needles: U.S. sizes 9 and 10 / 5.5 and 6 mm: 24 in / 60 cm circular

Gauge: 14 sts and 18 rows in pattern on larger needles = 4 x 4 in / 10 x 10 cm.
Adjust needle sizes to obtain correct gauge if necessary.

NECK WARMER
Holding 1 strand of each yarn together, with smaller size circular, CO 80 sts. Join, being careful not to twist cast-on row; place marker for beginning of round. Work 10 rnds k2, p2 ribbing. Change to larger size needle and work in lace pattern until neck warmer is desired length. The pattern is a multiple of 20 sts.

Rnd 1: *K1, (yo, sl 1, k1, psso) 3 times, (p1, k1tbl) 3 times, p1, (k2tog, yo) 3 times*; rep * to * around.
Rnd 2: Knit.
Rnd 3: *K2, (yo, sl 1, k1, psso) 3 times, (k1tbl, p1) 2 times, k1tbl, (k2tog, yo) 3 times, k1*; rep * to * around.
Rnd 4: Knit.
Rnd 5: *K3, (yo, sl 1, k1, psso) 3 times, p1, k1tbl, p1, (k2tog, yo) 3 times, k2*; rep * to * around.
Rnd 6: Knit.
Rnd 7: *Yo, sl 1, k1, psso, k2, (yo, sl 1, k1, psso) 3 times, k1tbl, (k2tog, yo) 3 times, k3*; rep * to * around.
Rnd 8: Knit. Move last st of round to beginning of next round.
Rnd 9: *Sl 1, k1, psso, yo, sl 1, k1, psso, k2, (yo, sl 1, k1, psso) 2 times, yo, sl 1, k2tog, psso, yo, (k2tog, yo) 2 times, k3, yo*; rep * to * around.
Rnd 10: Knit.
Rnd 11: *Yo, sl 1, k1, psso, k2, (k2tog, yo) 3 times, k1 tbl, (yo, sl 1, k1, psso) 3 times, k3* rep * to * around.
Rnd 12: Knit.
Rnd 13: *K3, (k2tog, yo) 3 times, p1, k1tbl, p1, (yo, sl 1, k1, psso) 3 times, k2* rep * to * around.
Rnd 14: Knit.
Rnd 15: *K2, (k2tog, yo) 3 times, (k1tbl, p1) 2 times, k1tbl, (yo, sl 1, k1, psso) 3 times, k1*; rep * to * around.
Rnd 16: Knit.
Rnd17: *K1, (k2tog, yo) 3 times, (p1, k1tbl) 3 times, p1, (yo, sl 1, k1, psso) 3 times*; rep * to * around.
Rnd 18: Knit. Move last st of round to beginning of next round.

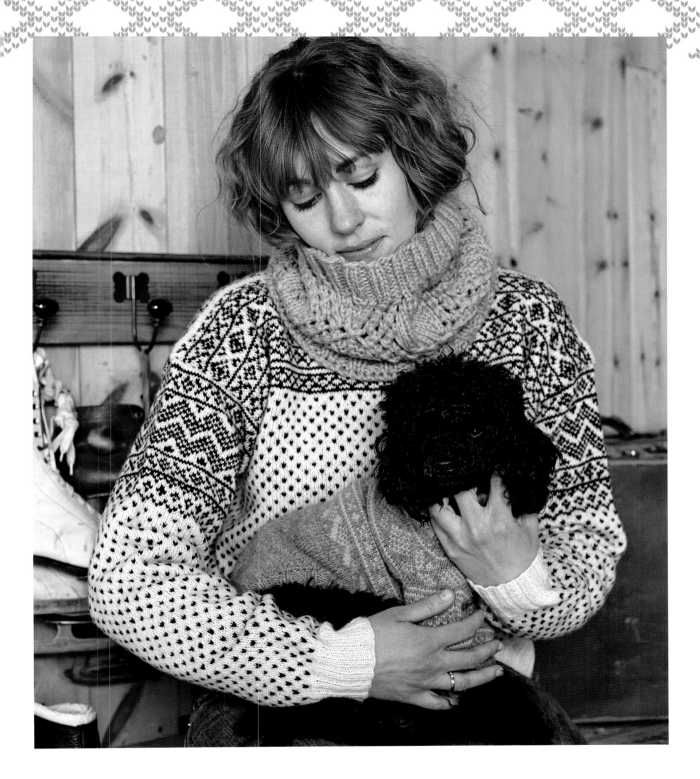

Rnd 19: *Sl 1, k2tog, psso, yo, (k2tog, yo) 2 times, (k1tbl, p1) 4 times, k1tbl, (yo, sl 1, k1, psso) 2 times, yo*; rep * to * around.
Rnd 20: Knit.

End with 10 rnds k2, p2 ribbing. BO loosely. Weave in ends neatly on WS. Lightly steam press neck warmer under a damp pressing cloth but do not press ribbing.

DOUBLE KNITTING

We have to admit that we have been bewitched by double knitting. Everyone knows that you can easily get hooked into knitting and this is so much fun that it is difficult to stop.

We learned double knitting by experimentation. Later on we found instructions for how it should be worked which were a bit different from our method but we didn't think they worked quite as well. So, here is how we work double knitting.

CO with alternating colors, 1 white, 1 blue. As you cast on, hold the two strands of each color on the same side of the needle throughout. In this case, the blue yarn is held at the front of the needle while you make each white stitch and vice versa. Begin with a

slip knot each of blue and white (photo 2). Make sure there is enough of the loose hanging strand of each color for the number of stitches you need. CO 1 with white, using long-tail cast-on, and leave strands behind needle. CO 1 with blue and leave strands in front of needle (photos 3 and 4).

When you turn the work to knit the first row (photo 5), the white strand will be facing you at the front of the work while the blue yarn will be at the back. This means that the blue yarn will be purled and the white yarn knitted.

Here is how to work solid-color double knitting:
On the first row, slip the 1st two sts while you hold the strands you are knitting with between the 2 sts

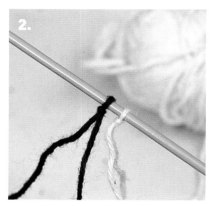
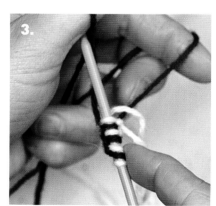
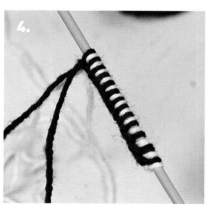
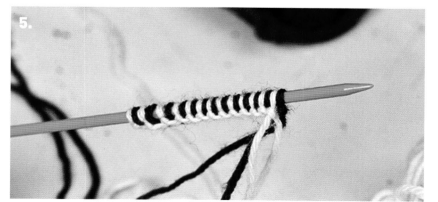

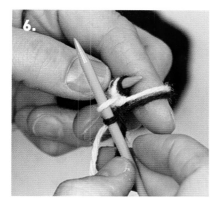
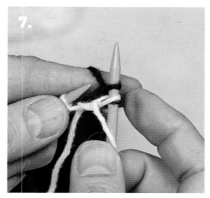
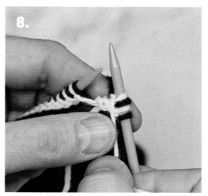
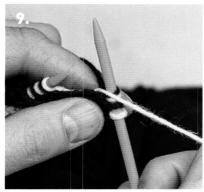

(photo 6). Place the blue strand (purl) on your finger (photo 7) and *bring the white towards you, between the sts, to the front of the work and purl the 1st blue st; take the white yarn to back of work and knit the 1st white st*. Repeat from * to * across. When you come to the end of the row, twist the strands and work back the same way, noting that now the white sts are purled and blue sts knitted.

DOUBLE KNIT PATTERNS
When you work patterns in double knitting, always think in pairs. The knit st is always the opposite color of the purl st. If you want to knit a blue st next to a white knit st and the white sts are on the facing RS and the blue sts on facing WS, change the positions of the colors (photos 9-11).

Here's how to double knit a pattern: Place the white yarn on your finger, *bring the blue towards you, between the sts, to front of work, and purl the 1st blue st with white; take blue strand to back of work and knit the 1st white st with blue yarn*.

If you cast on without crossing the colors, you will soon notice whether the lower edge was worked with blue or white. Continue working in pattern, following the chart, and don't forget that the knit st is always the opposite color of the purl st so that the pattern on one side is the reverse image of the other side.

In other descriptions of double knitting, the first two sts are always knitted together with the 2 colors held together. This makes a somewhat sloppy barber pole edge. We prefer to slip both sts, leaving the edge open between the layers. It is actually rather nice to see that you have knitted double. When the pattern begins, the layers will be bound together.

BINDING OFF
We bind off by switching the first two sts so that they can be bound off with the same color. We twist the needle so that each color can be bound off with the same color thus binding off every other stitch across. Double knitting is usually looser than regular knitting so go down a needle size or two if you notice that the piece is too loosely knitted.

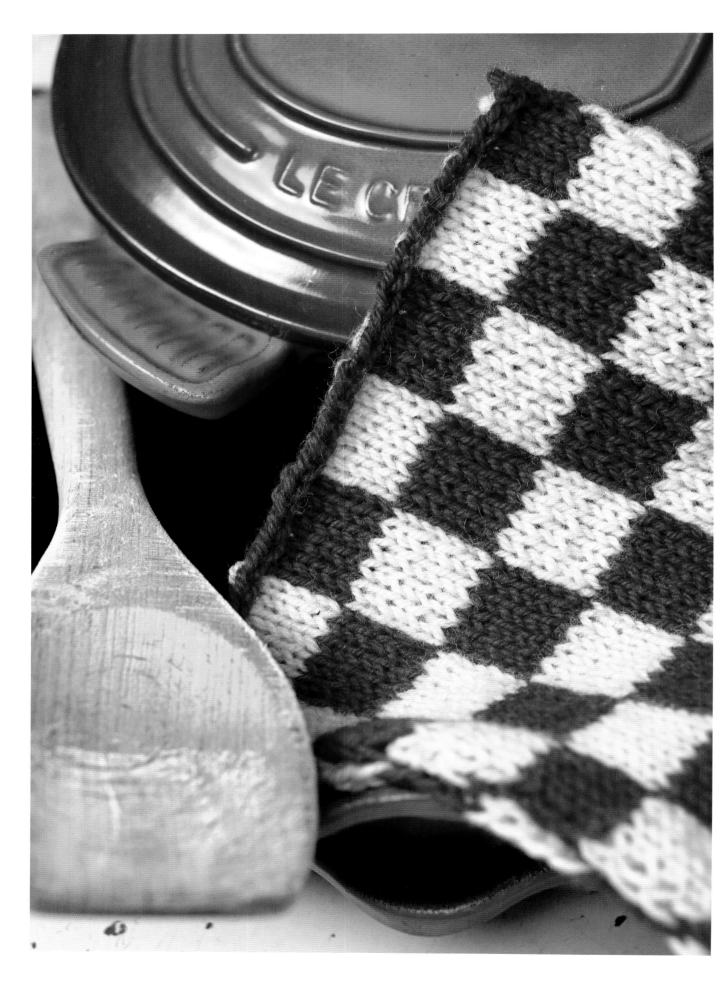

CHECKERBOARD
POTHOLDER

This is the easiest double knitting pattern in the book. If you have not done any double knitting before, this is a good place to start.

FINISHED MEASUREMENTS
7 x 7 in / 18 x 18 cm after blocking. This potholder will vary in size and be larger than if worked in regular two-color stranded knitting.

MATERIALS
Yarn: (CYCA #3), Rauma 3-ply Strikkegarn, 100% wool (115 yd/105 m / 50 g)
Yarn Amounts:
Color 1: Red 174, 50 g
Color 2: White 101, 50 g

Needles: U.S. size 4 / 3.5 mm

Gauge: 20 sts and 28 rows = 4 x 4 in / 10 x 10 cm. Adjust needle size to obtain correct gauge if necessary.

POTHOLDER
CO 35 sts with each color in double knitting cast-on (see page 132). Work back and forth in double knitting following the chart. The first row of the chart = cast-on row.
You should be able to see from the cast-on row which sts are knit and which are purled. The stitch facing you closest is knit and the stitch behind is purled.

Before binding off, see instructions on page 133. BO with red on the red side and white on the white side so the colors will match those of the cast-on row.

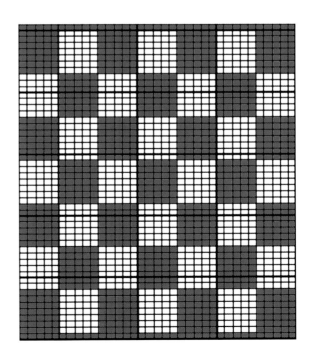

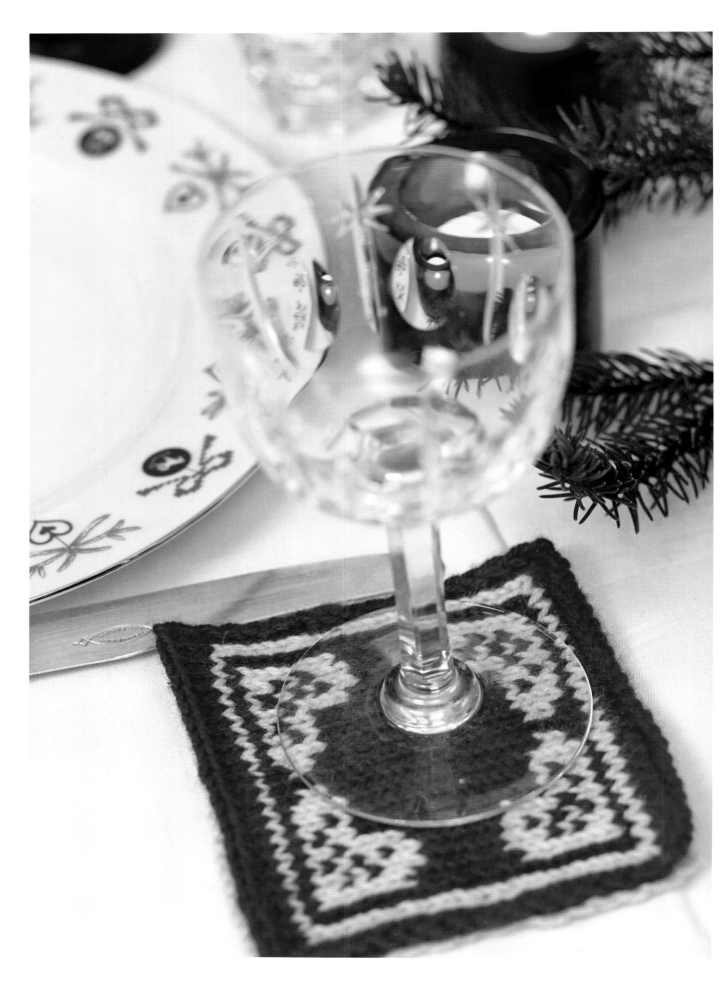

If you had success knitting the potholder, then you are ready for more double knitting. This pattern is only slightly more difficult.

COASTERS
WITH HEARTS FOR CHRISTMAS

FINISHED MEASUREMENTS
Approx. 4¾ x 4¾ in / 12 x 12 cm after blocking

MATERIALS
Yarn: (CYCA #3), Rauma 3-ply Strikkegarn, 100% wool (115 yd/105 m / 50 g)
Yarn Amounts:
Color 1: Red 144, 50 g
Color 2: White 101, 50 g

Needles: U.S. size 4 / 3.5 mm

Gauge: 20 sts and 28 rows = 4 x 4 in / 10 x 10 cm. Adjust needle size to obtain correct gauge if necessary.

COASTERS
CO 25 sts with each color in double knitting cast-on (see page 132). Work back and forth in double knitting, following the chart. The first row of the chart = cast-on row.

Before binding off, see instructions on page 133. BO with red on the red side and white on the white side so the colors will match those of the cast-on row.

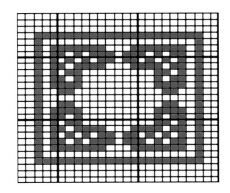

It just gets better and better, so full speed ahead now.
We made these coasters to place under wine glasses with
Christmas motifs.

COASTERS
WITH CROSSES FOR CHRISTMAS

FINISHED MEASUREMENTS
Approx. 4¾ x 4¾ in / 12 x 12 cm after blocking

MATERIALS
Yarn: (CYCA #3), Rauma 3-ply Strikkegarn, 100%
wool (115 yd/105 m / 50 g)
Yarn Amounts:
Color 1: Red 144, 50 g
Color 2: White 101, 50 g

Needles: U.S. size 4 / 3.5 mm

Gauge: 20 sts and 28 rows = 4 x 4 in / 10 x 10 cm.
Adjust needle size to obtain correct gauge if
necessary.

COASTERS
CO 25 sts with each color in double knitting cast-on
(see page 132). Work back and forth in double knitting
following the chart. The first row of the chart = cast-
on row.

Before binding off, see instructions on page 133. BO
with red on the red side and white on the white side
so the colors will match those of the cast-on row.

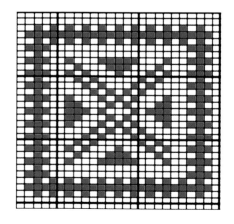

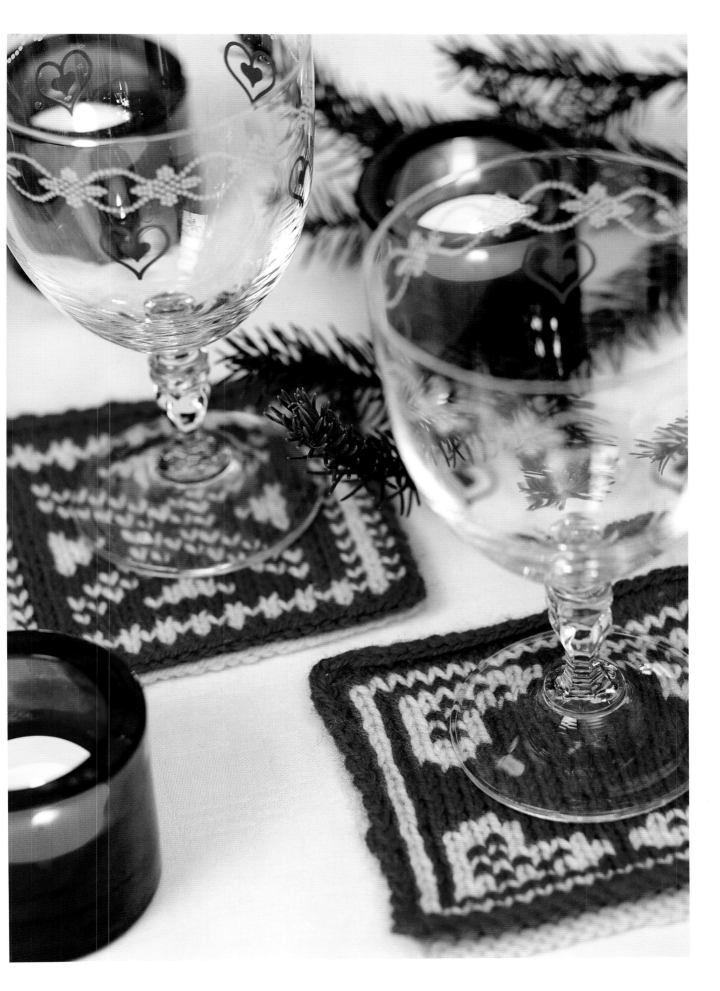

How about knitting your own computer mouse pad with a wool
and alpaca yarn?

MOUSE PAD

FINISHED MEASUREMENTS
Approx. 9 x 9 in / 22.5 x 22.5 cm after blocking

MATERIALS
Yarn: (CYCA #3), Rauma Mitu, 50% superfine alpaca
and 50% wool yarn (109 yd/100 m / 50 g)
Yarn Amounts:
Color 1: Green 6315, 50 g
Color 2: Black SFN50, 50 g

Needles: U.S. size 4 / 3.5 mm

Gauge: 20 sts and 28 rows = 4 x 4 in / 10 x 10 cm.
Adjust needle size to obtain correct gauge if
necessary.

You can also use this pattern for a potholder or
coaster. If you worked the first three patterns, you are
ready for more double knitting and this will be child's
play.

PAD
CO 45 sts with each color in double knitting cast-on
(see page 132). Work back and forth in double knit-
ting, following the chart. The first row of the chart =
cast-on row.

Before binding off, see instructions on page 133. BO
with green on the green side and black on the black
side so the colors will match those of the cast-on row.

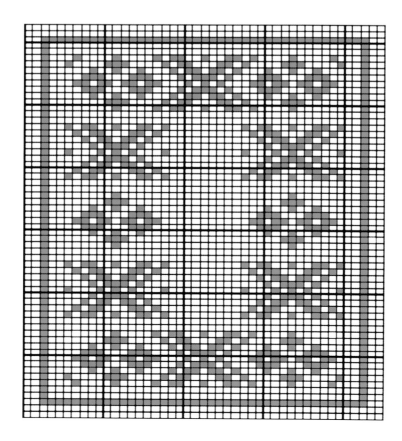

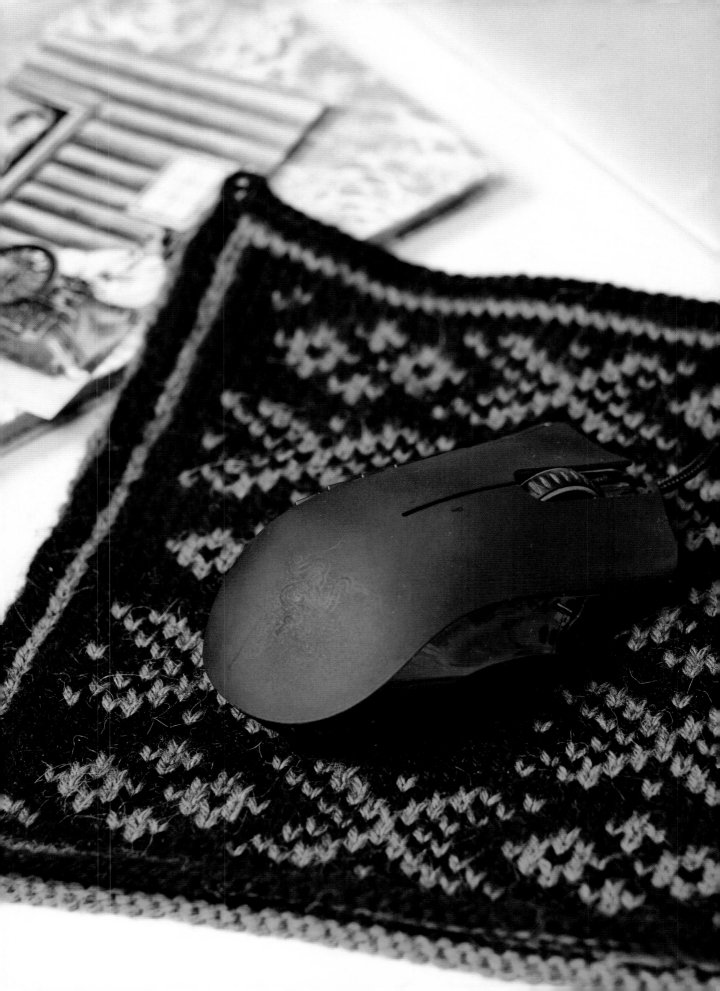

YARNS

Rauma yarns distributed in the USA by:

Mango Moon Yarns
info@mangomoonyarns.com
www.mangomoonyarns.com

Nordic Fiber Arts
info@nordicfiberarts.com
www.nordicfiberarts.com

The Yarn Guys
info@theyarnguys.com
http://theyarnguys.com/

Ingebretsen's
info@ingebretsens.com
www.ingebretsens.com

Rauma Ullvarefabrikk:
www.raumaull.no

These companies supply yarns that can be substituted for Rauma yarns if necessary:

Sandnes Garn:
www.sandnesgarn.no
Dalegarn:
www.dalegarn.com

Hillesvåg Ullvarefabrikk:
www.ull.no (or, in USA, www.nordicfiberarts.com)

BIBLIOGRAPHY

Bondesen, Esther. *Den Nye Strikkeboken* [The New Knitting Book]. Oslo, Norway: Ansgar Forlag, 1948.

Høye, Gert M. *Sosialmedisinske undersøkelser i Valle*, Setesdal [Social Medicine Research in Valle, Setesdal]. Oslo, Norway: A. W.Brøggers Boktrykkeri A/S, 1941.

Noss, Aagot. *Stakklede i Setesdal* [Folk Costumes in Setesdal].Oslo, Norway: Novus Forlag, 2008.

Sibbern Bøhn, Annichen. *Norske Strikkemønstre*. Oslo, Norway, 1929, 1947. *Norwegian Knitting Designs*, reprint, Seattle, 2011

Skar, Johannes. *Gamalt or Setesdal I, II, and III* [Old Ways in Setesdal]. Oslo, Norway: Det Norske Samlaget, 1963.

Sundbø, Annemor. *Lusekofta fra Setesdal*. Oslo. Norway: Høyskoleforlaget AS, 1998. *Setesdal Sweaters: The History of the Norwegian Lice Pattern*. Kristiansand, Norway: Torridal Tweed, 2001.

Sundbø, Annemor. *Strikking i Billdekunsten/Knitting in Art*. Kristiansand, Norway: Torridal Tweed, 2010.

Sundbø, Annemor. *Kvardagsstrikk*. Oslo, Norway: Det Norske Samlaget, 1994. *Everyday Knitting: Treasures from a Ragpile*. Kristiansand, Norway: Torridal Tweed, 2000.

Sundbø, Annemor. *Usynlege trådar i Strikkekunsten*. Oslo: Det Norske Samlaget, 2005. *Invisible Threads in Knitting*. Kristiansand, Norway: Torridal Tweed, 2007.

Svensøy, Kari Grethe. *Det va inkje hobby; det var arbeid*. Tekstilarbeidet i Bykle ca 1900-1935 [It wasn't a Hobby, it was Work: Textile Work in Bykle from about 1900-1935]. Magisteravhandling i etnologi. Institutt for Etnologi. Universitet i Oslo. 1987.

Norsk Folkemuseum. *Setesdalen*. Kristiania (Oslo), Norway: Alb Cammermeyers Forlag. Lars Swanström. 1919.

Thank you to **Bodil Svanemyr** for her invaluable help with developing the patterns for the sweaters, stockings, and mittens. Thank you also to **Laila Kristin Wilgunnsdottir Bøhle** and **Britt Aasen Brude** for help in knitting the models. We would never have accomplished this book without you!

If you want to see more pieces in the Christmas service, see www.fyrklovern.se.

Here is a schematic for the quilt on page 70. We omitted the colors so you can use your own creativity for arranging the colors.